Coloring Books for Adults

Stress Relieving Design

ANIMALS

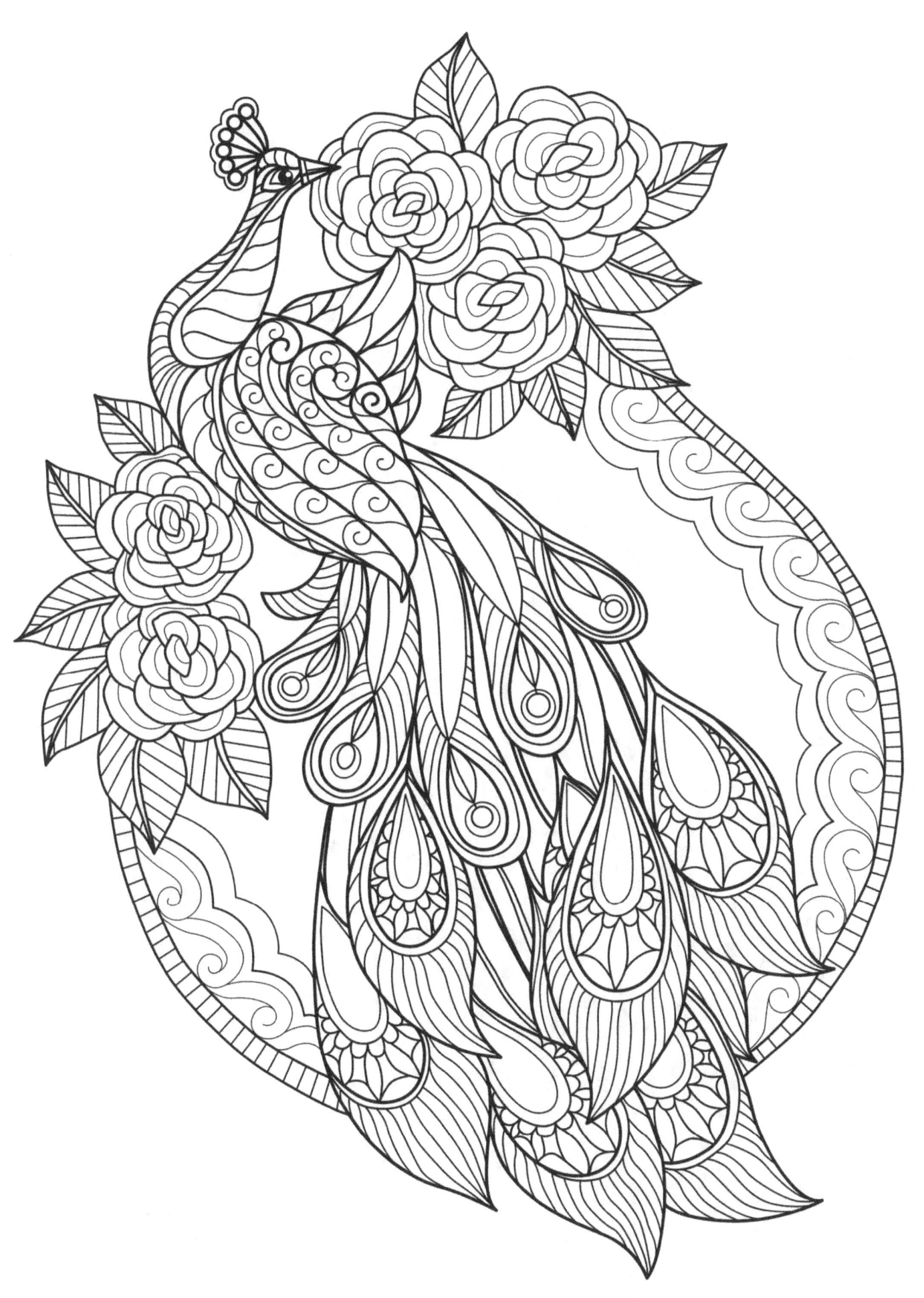

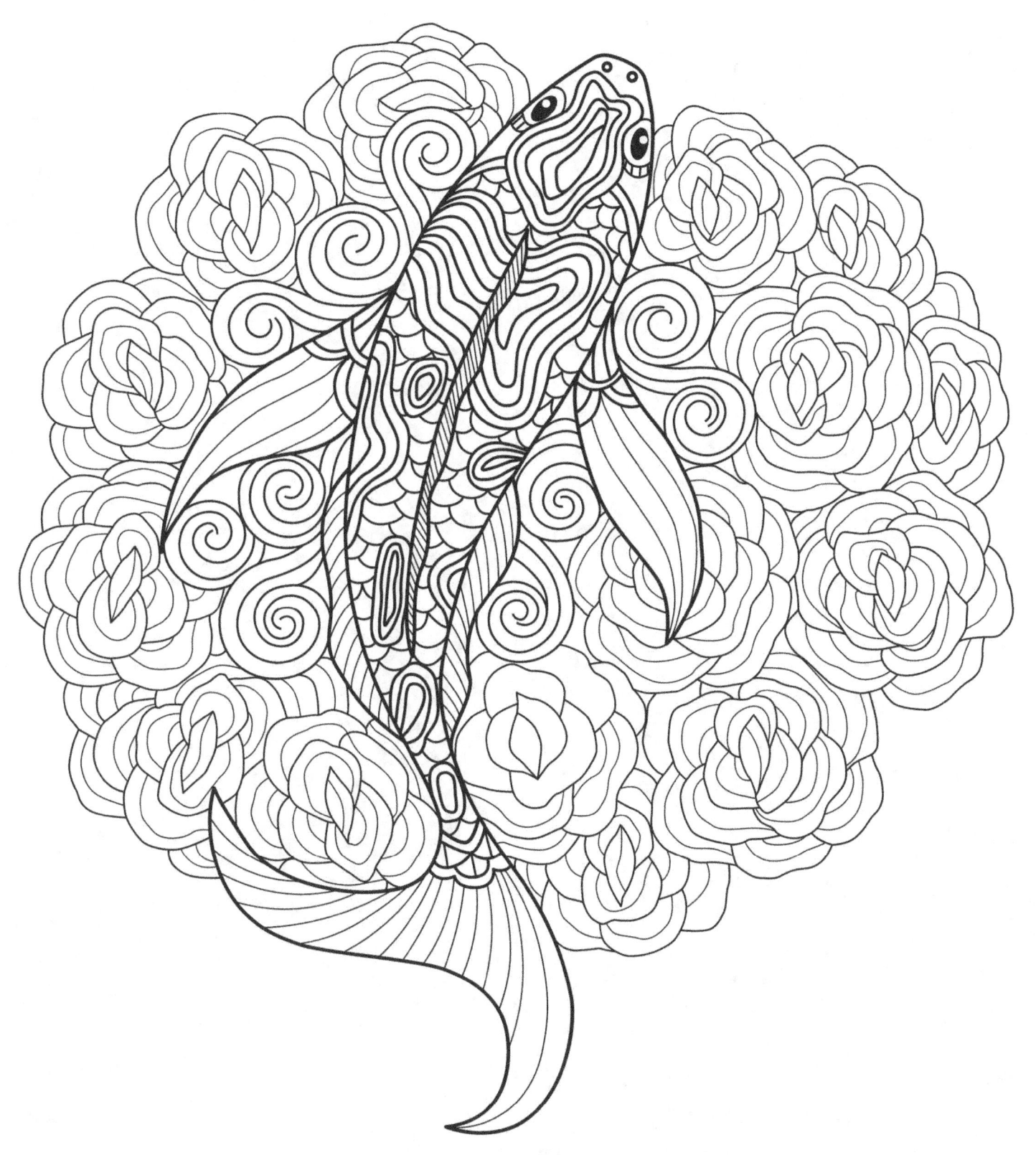

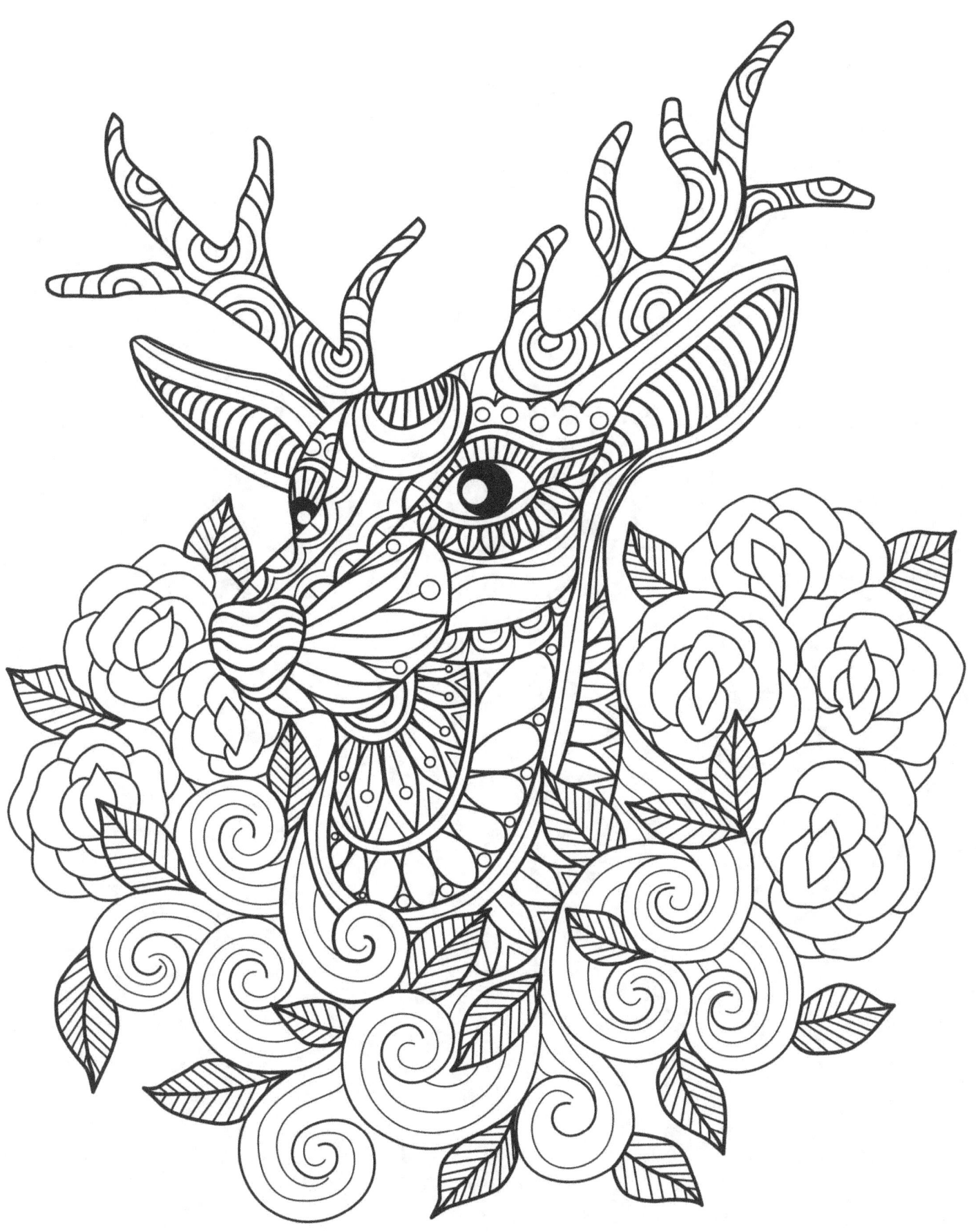

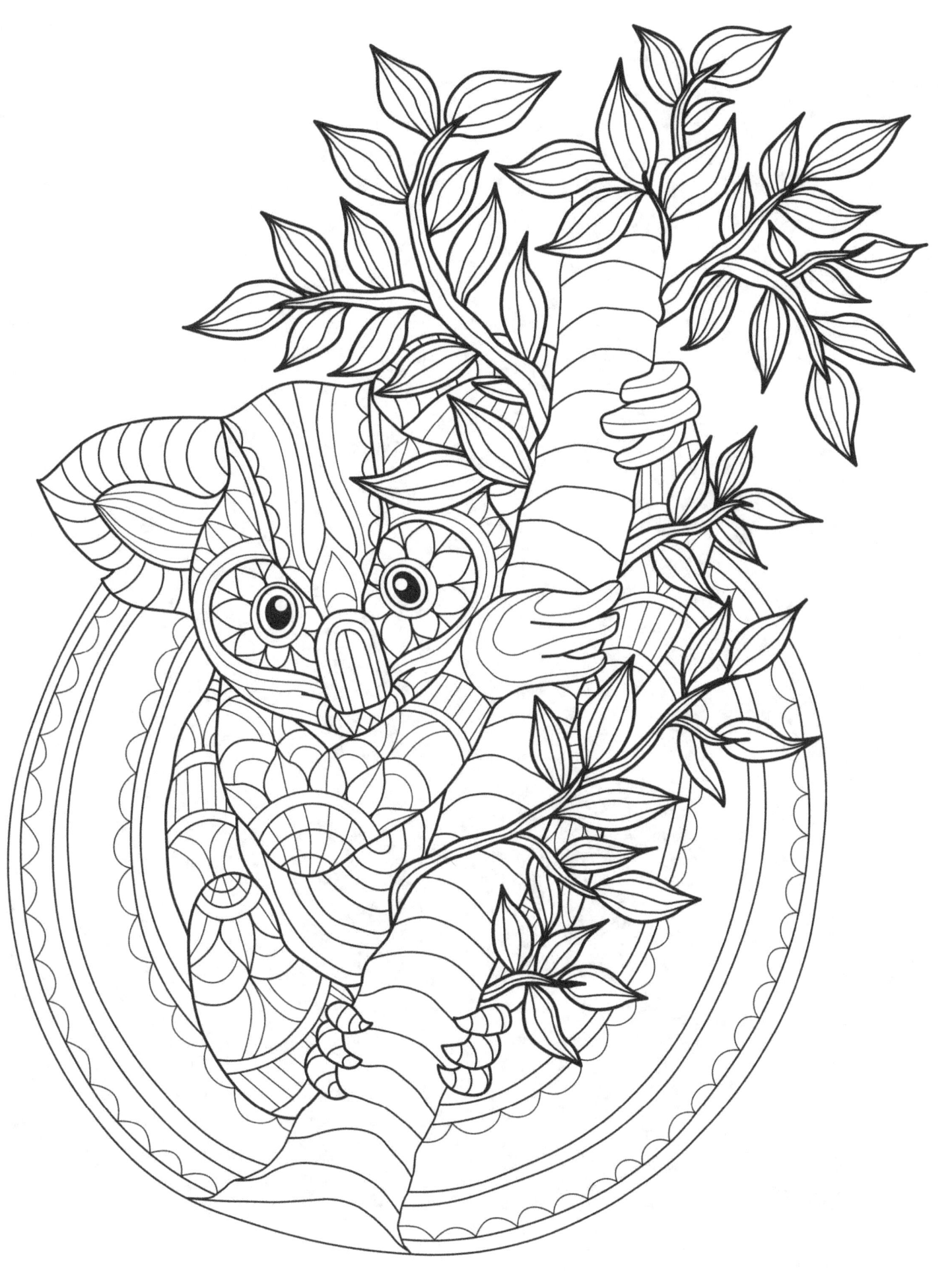

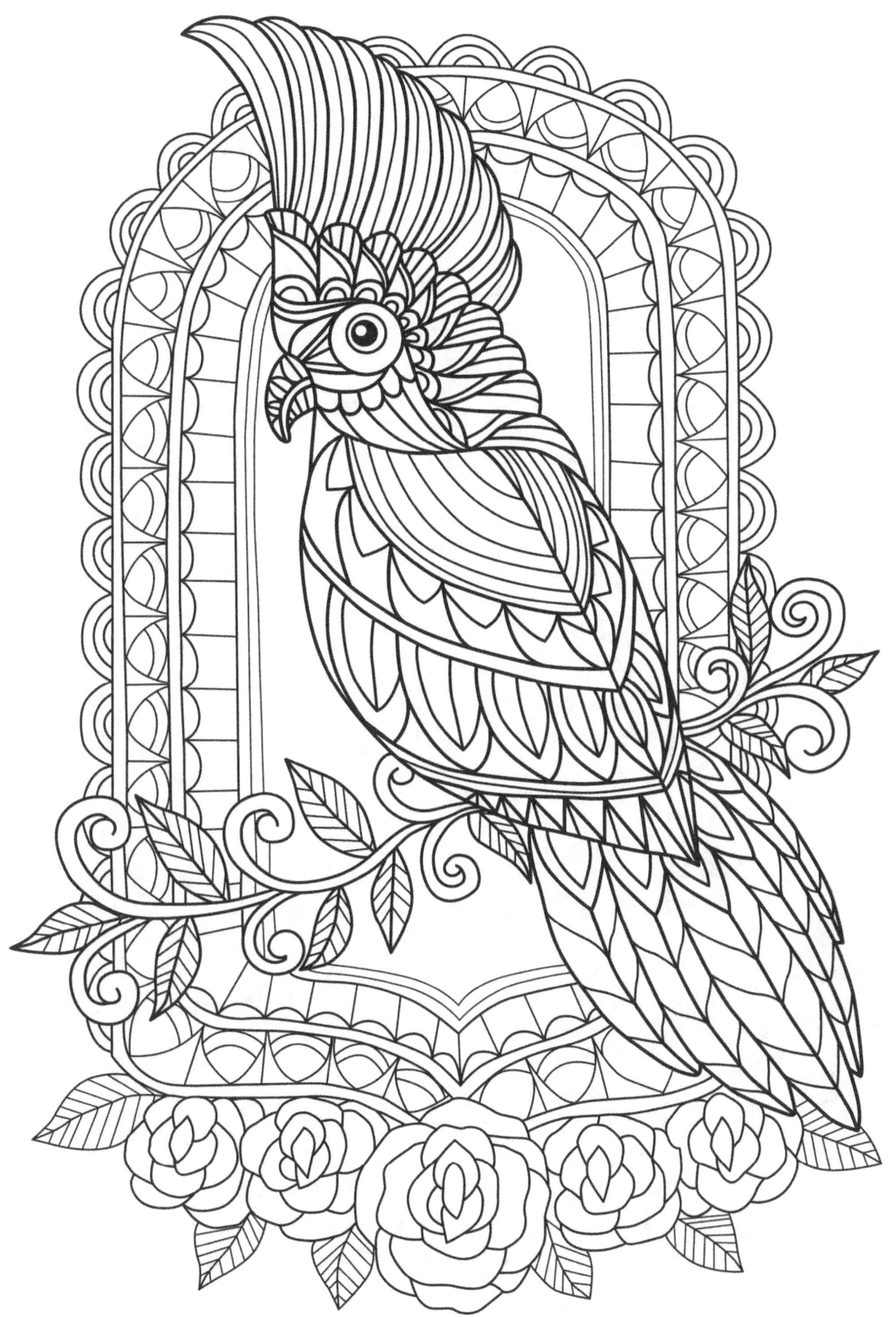

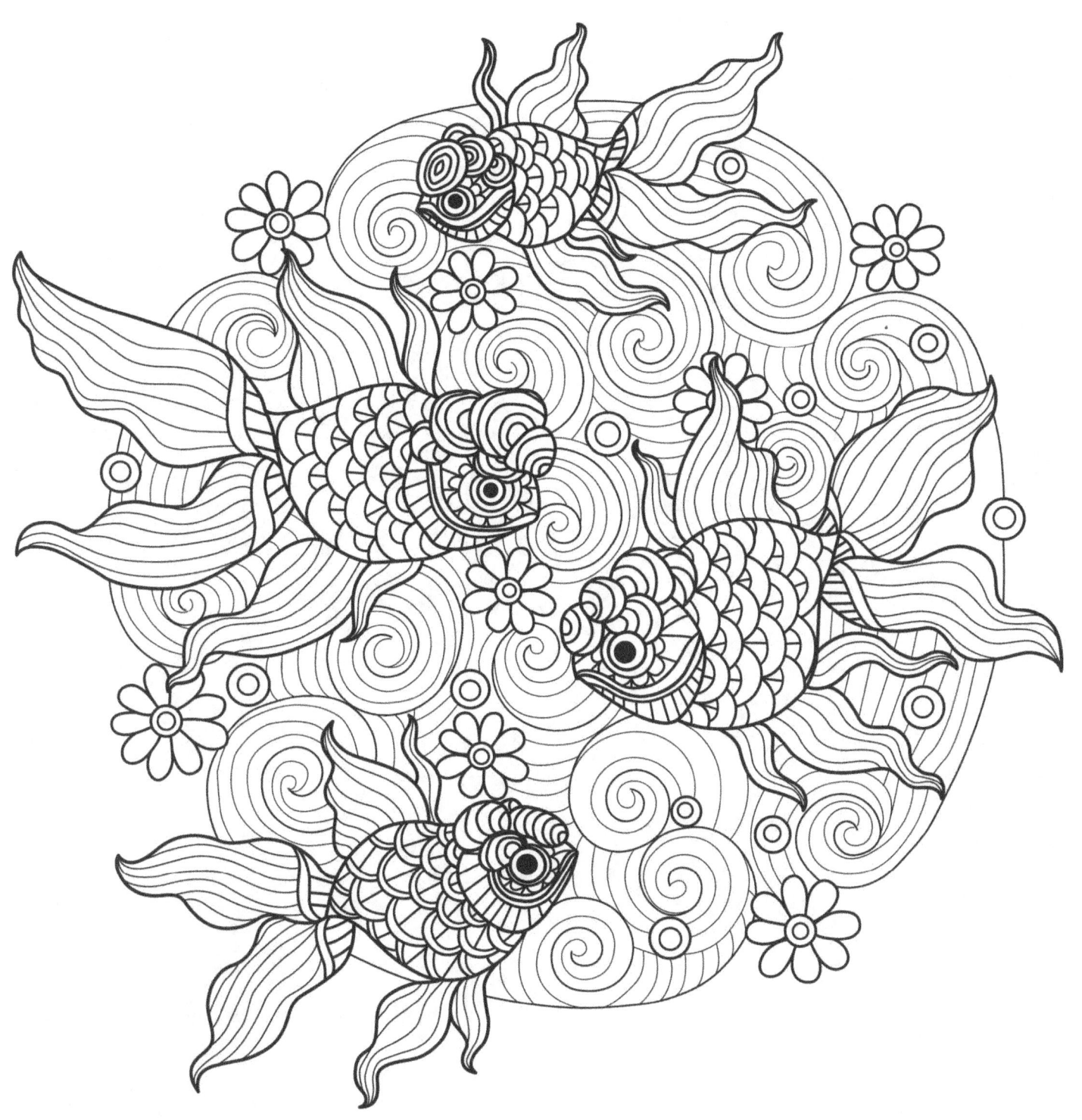

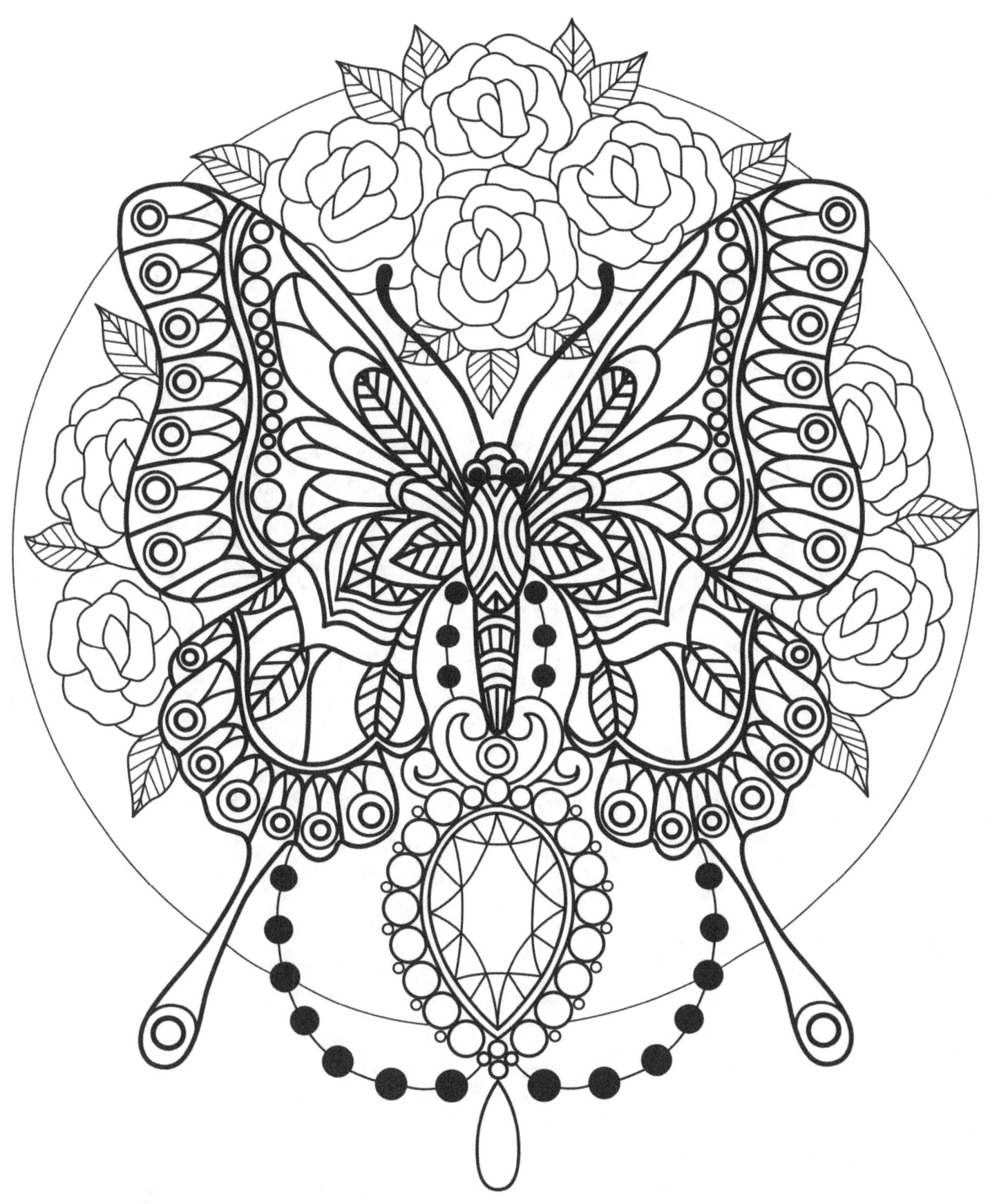

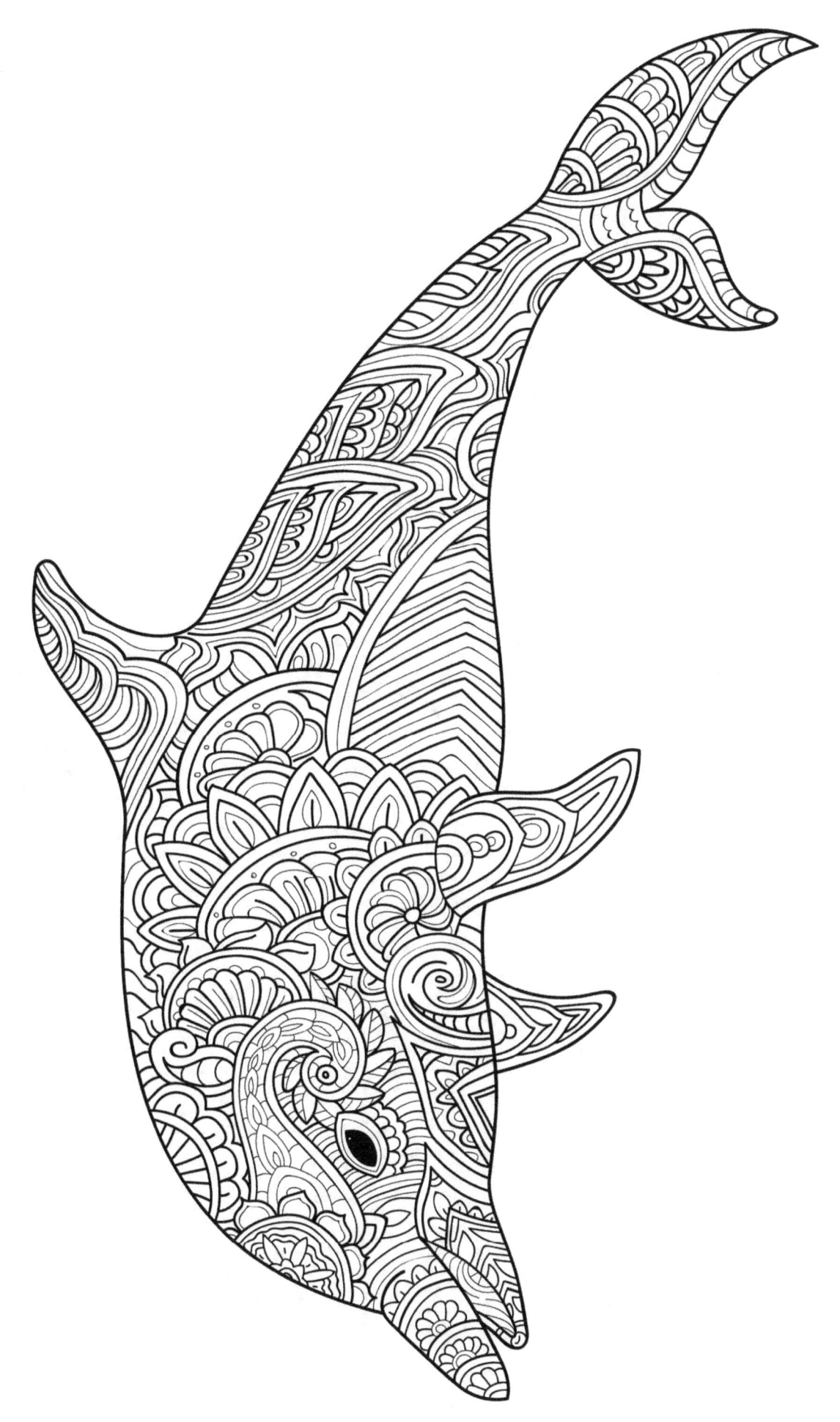

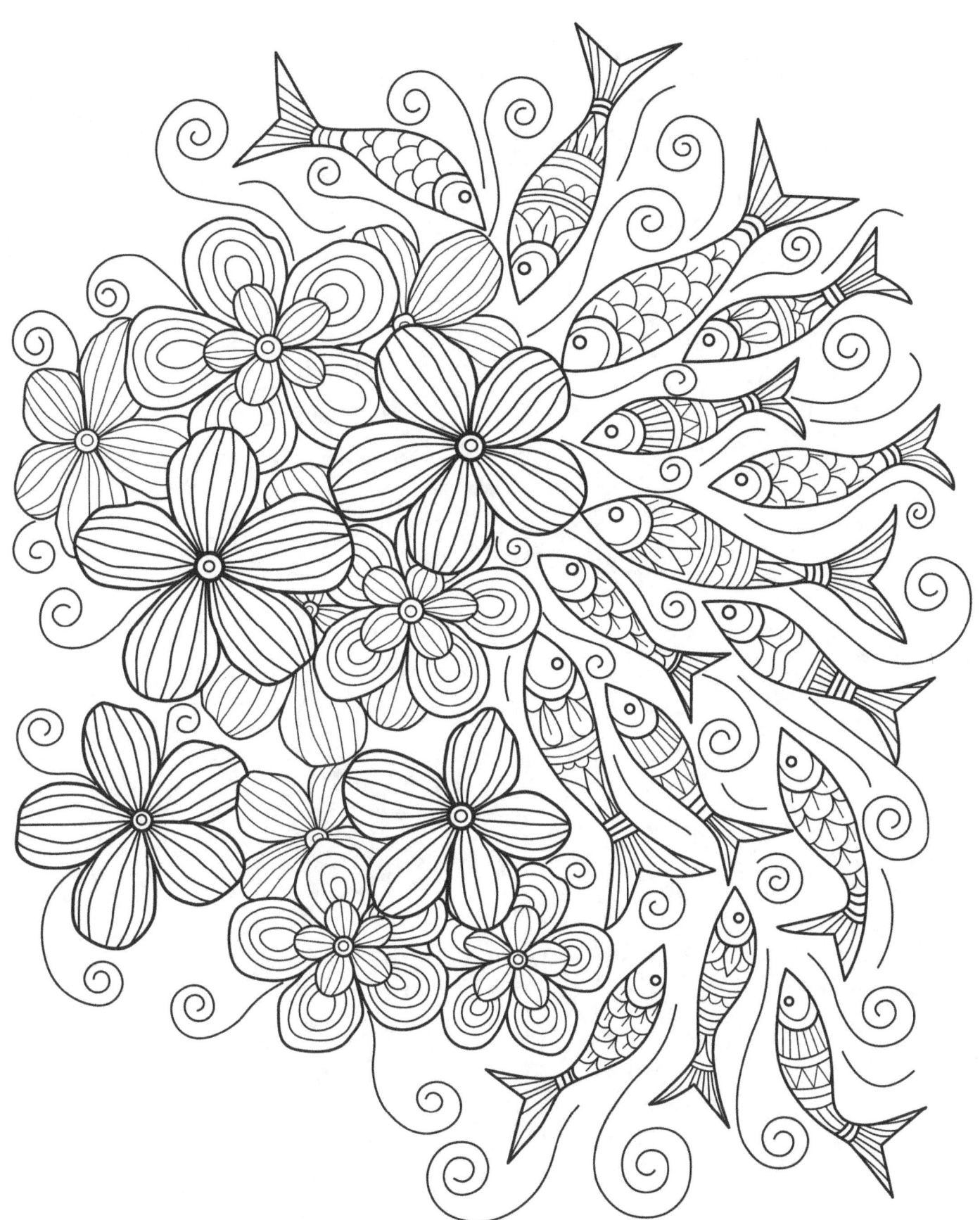

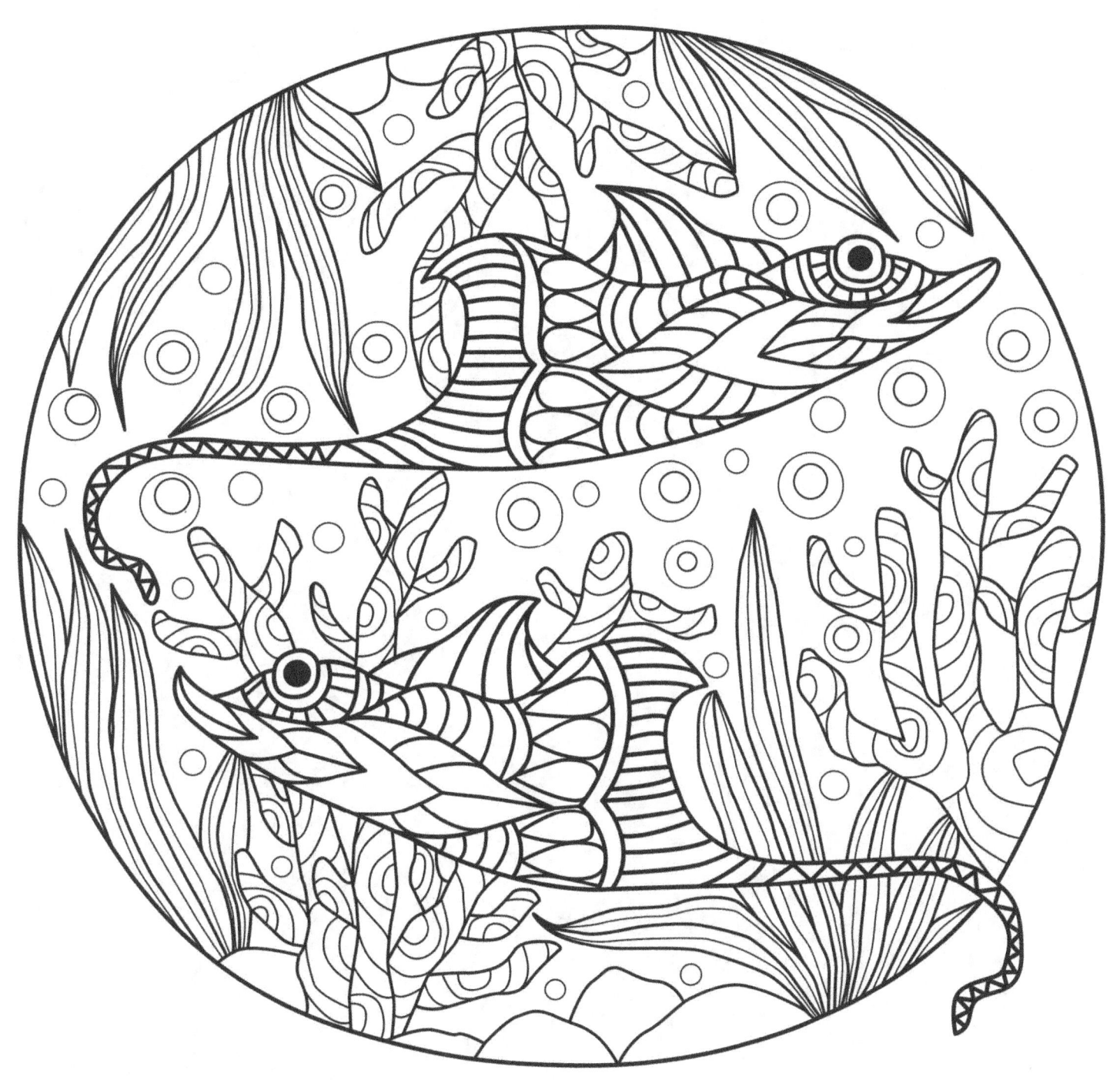

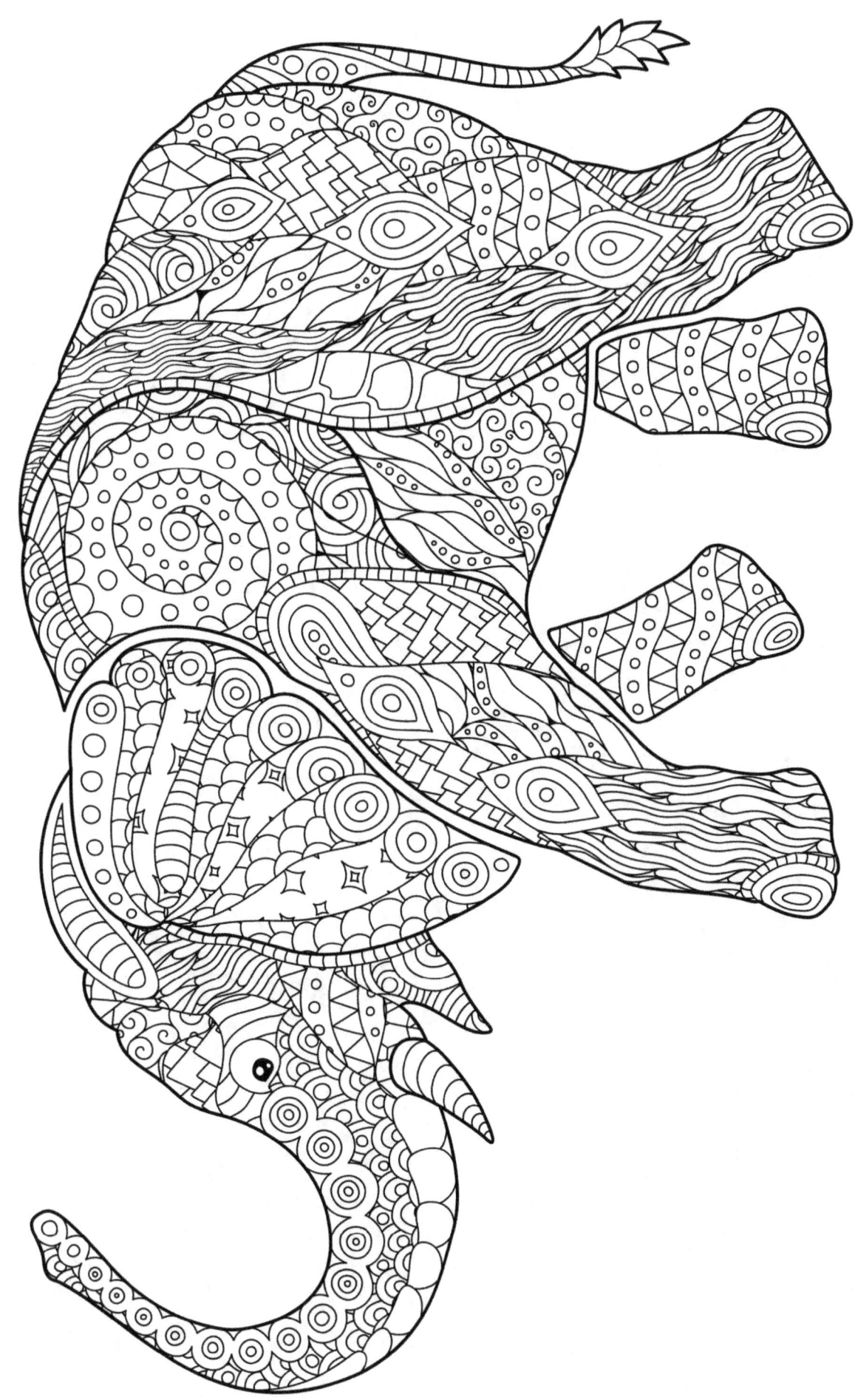

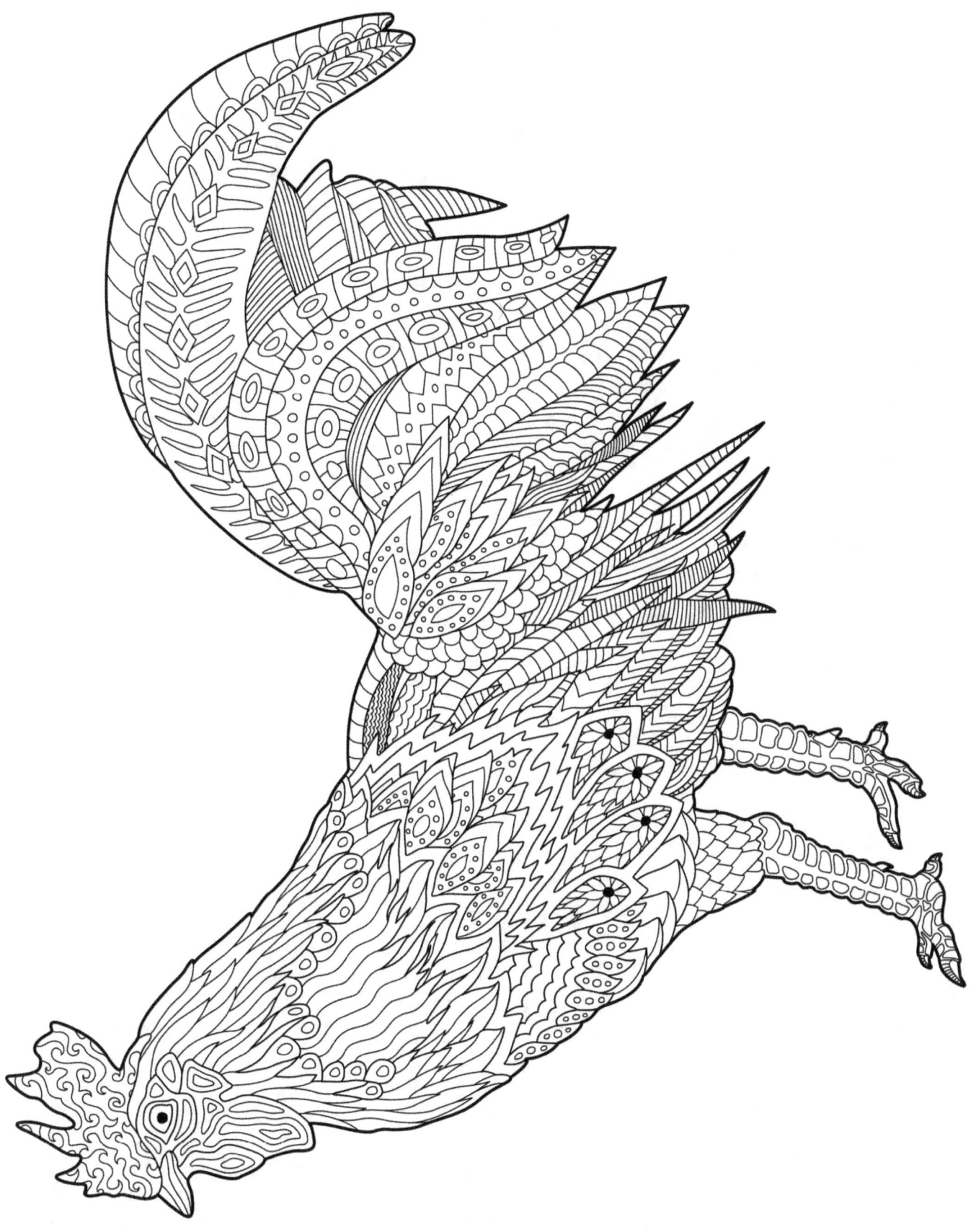

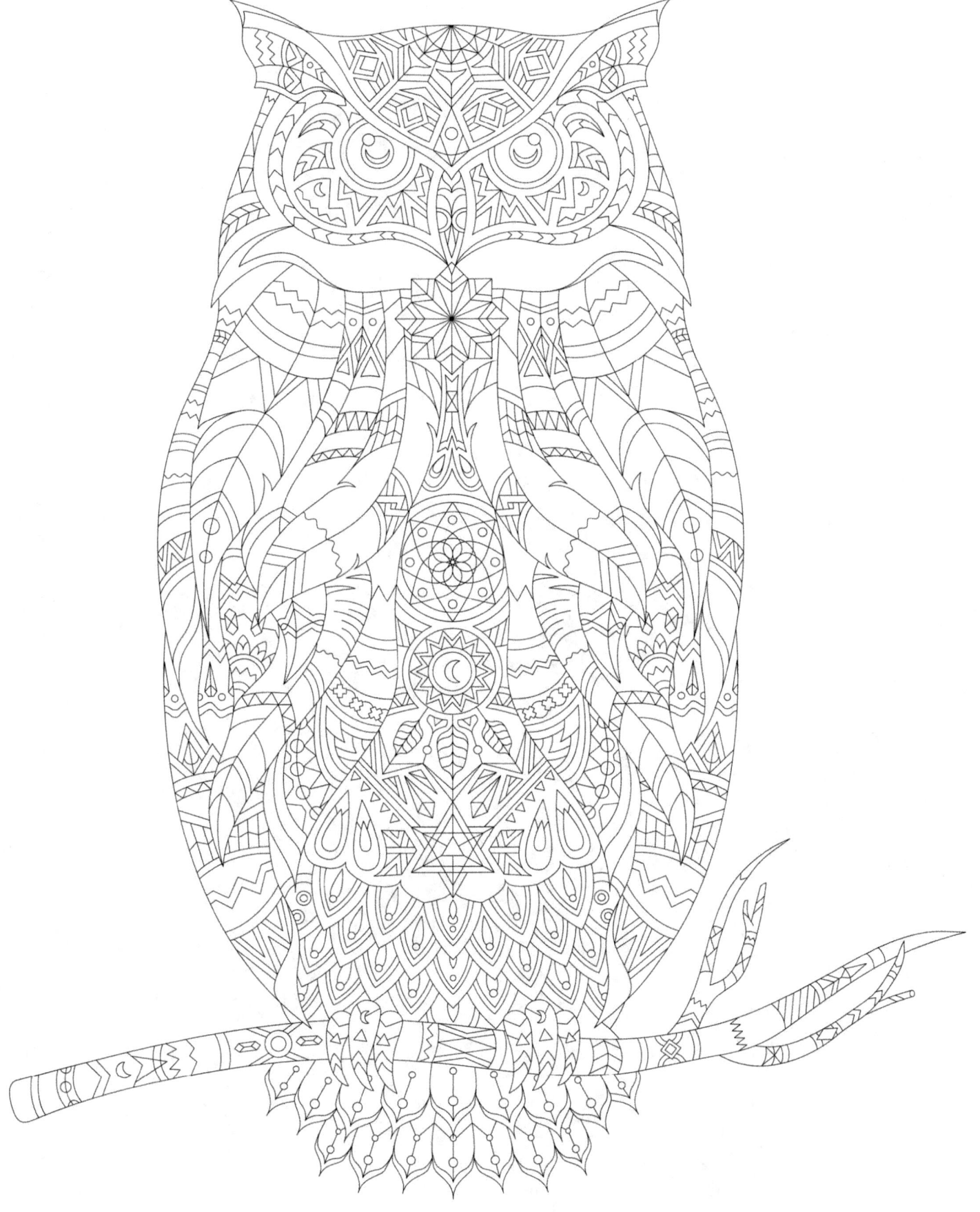

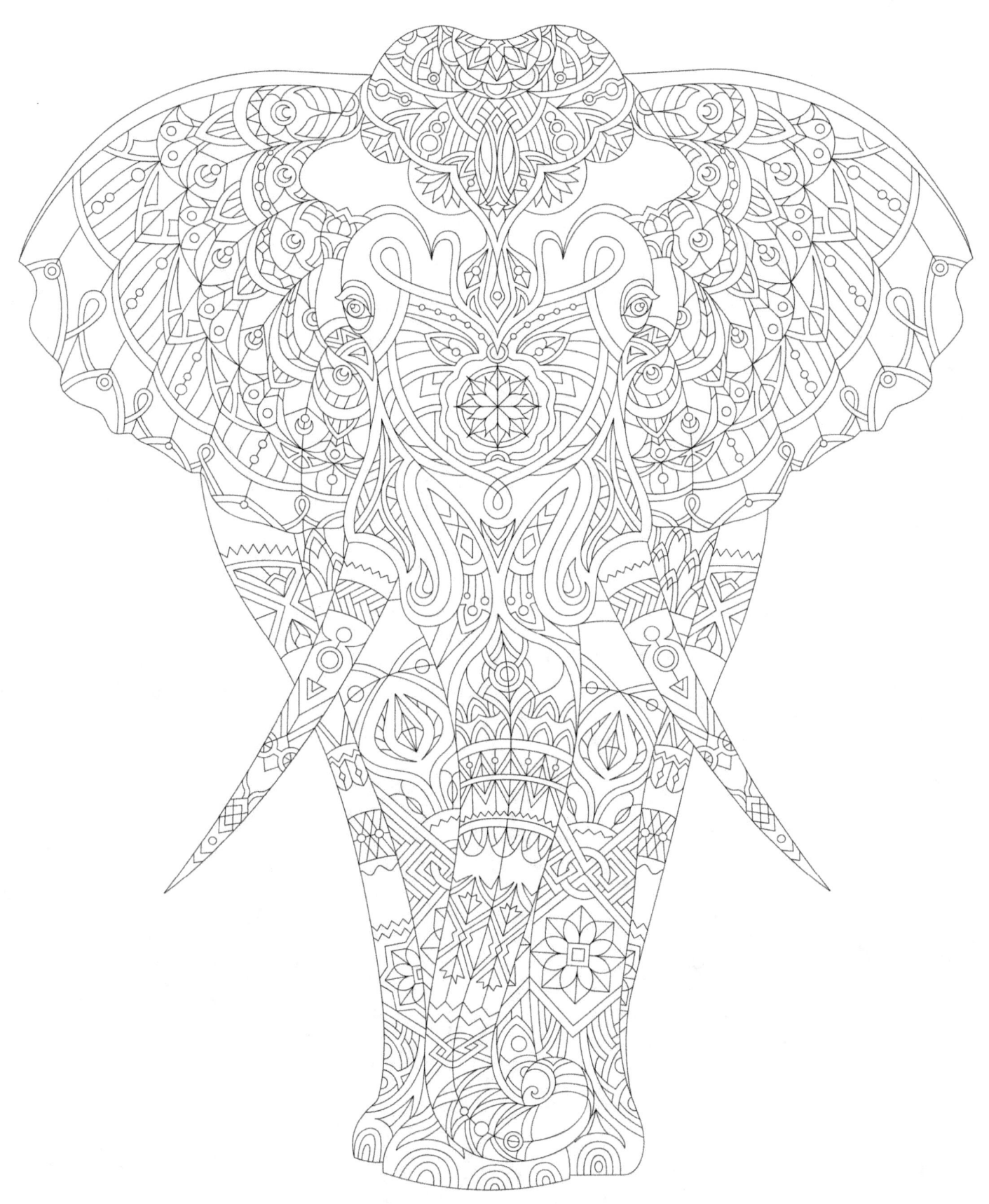

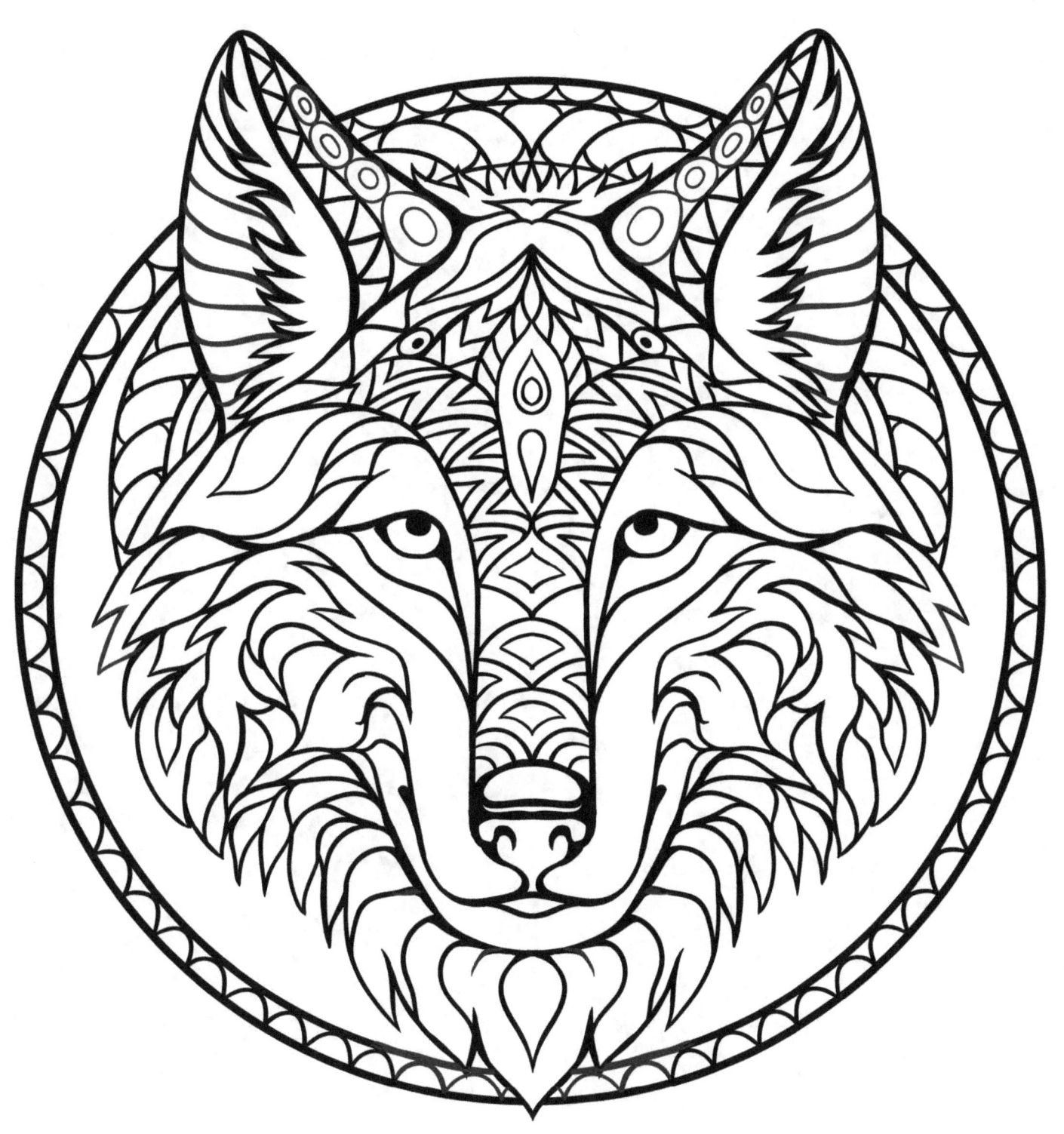

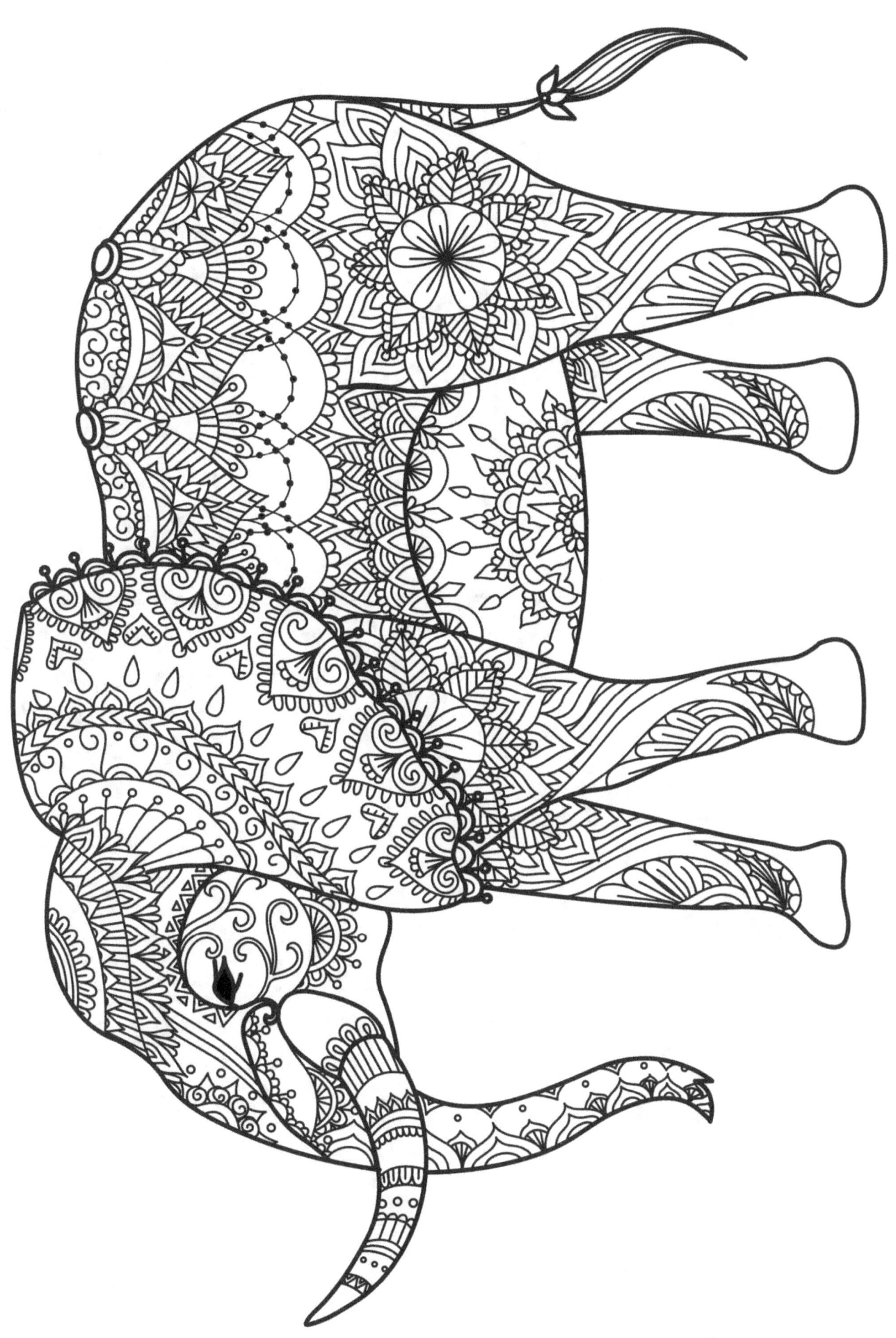

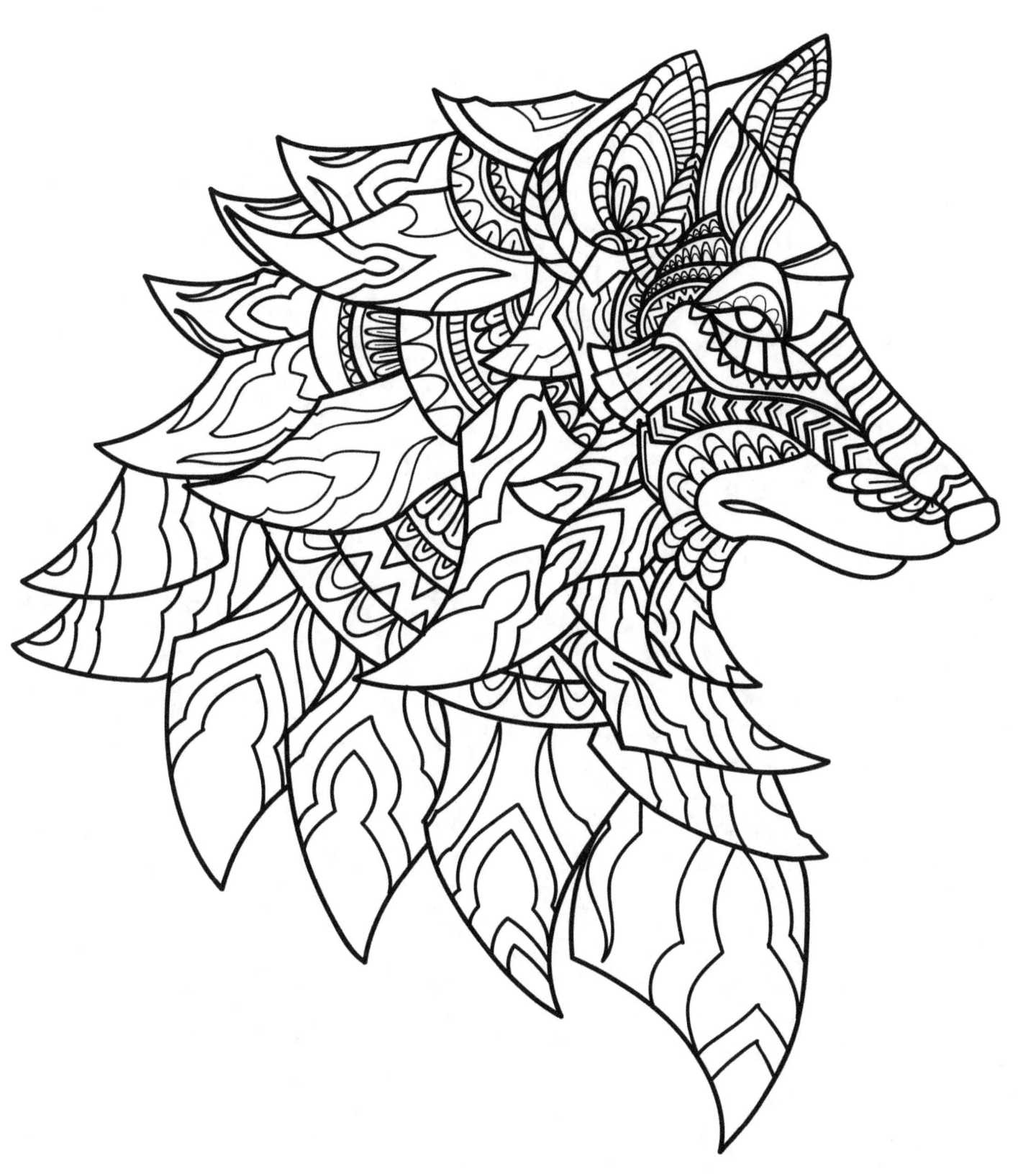

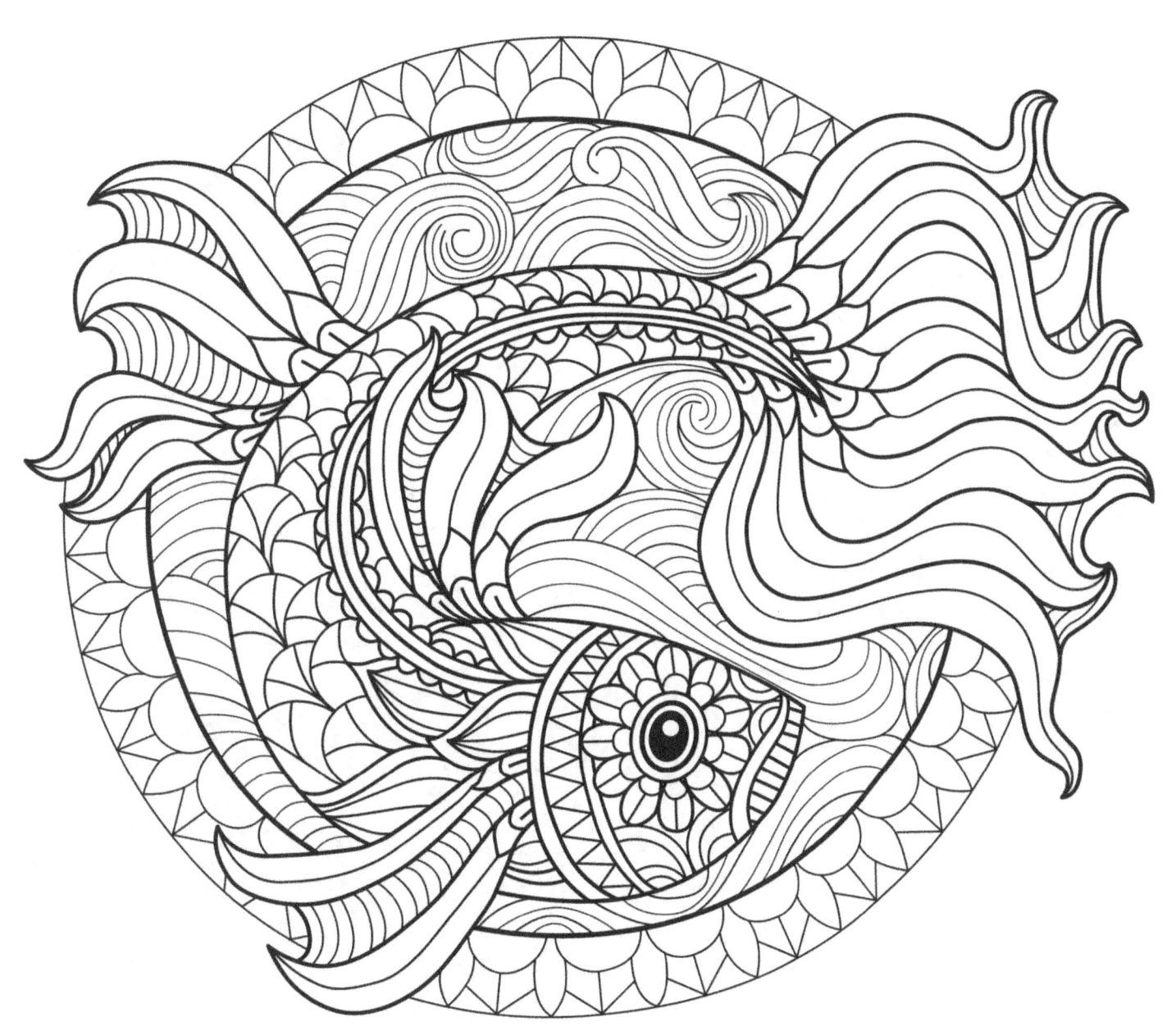

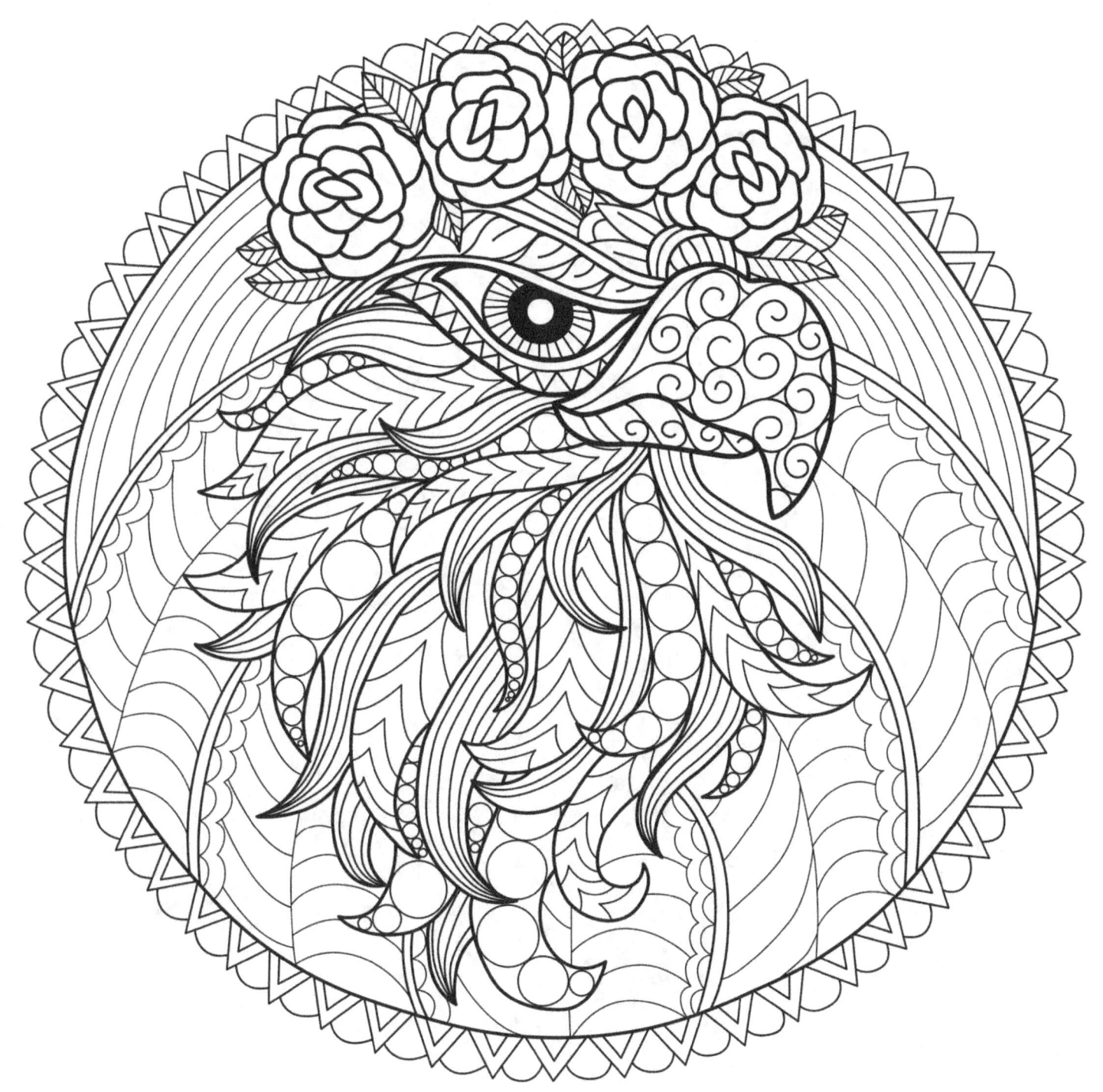

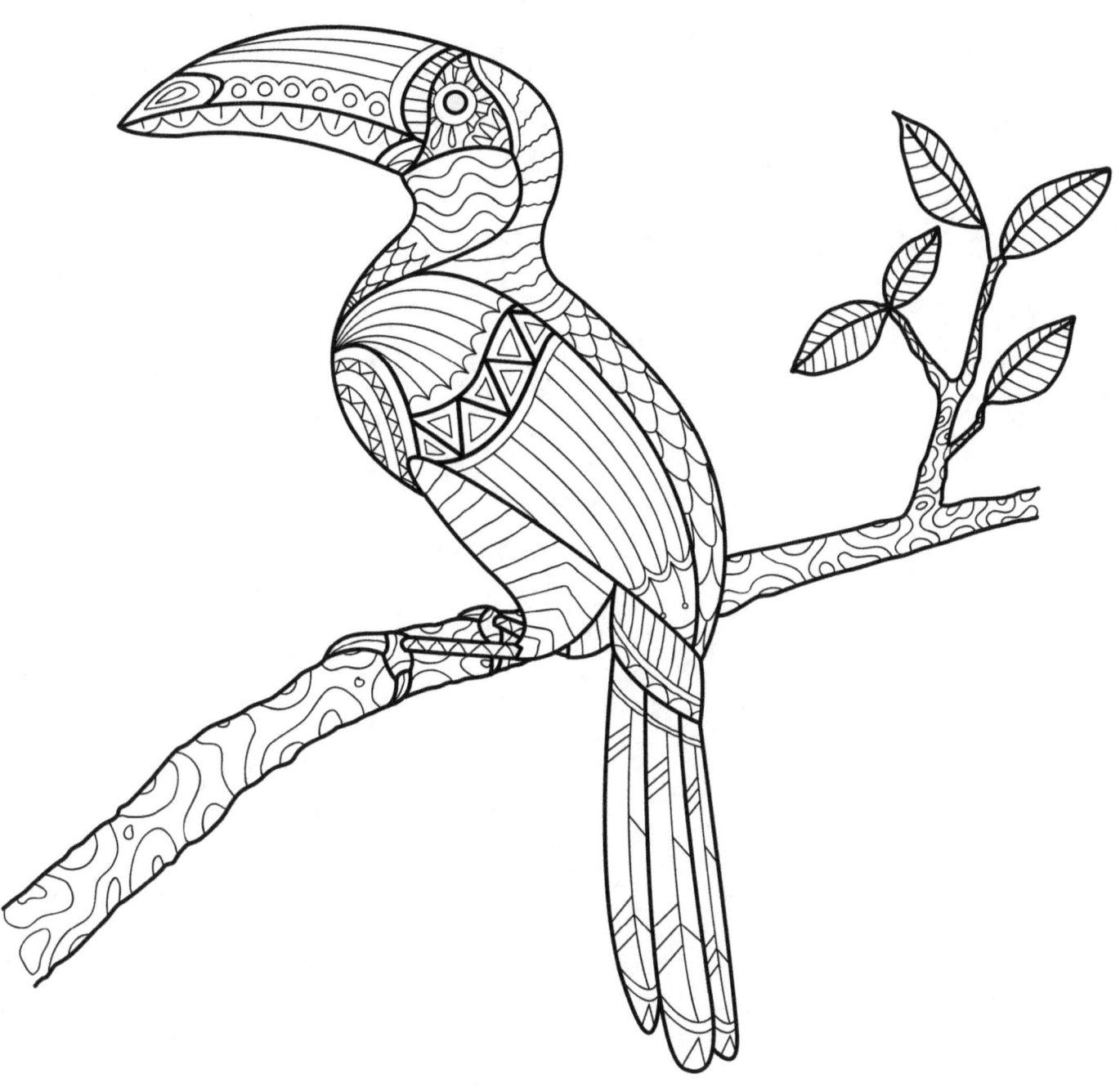

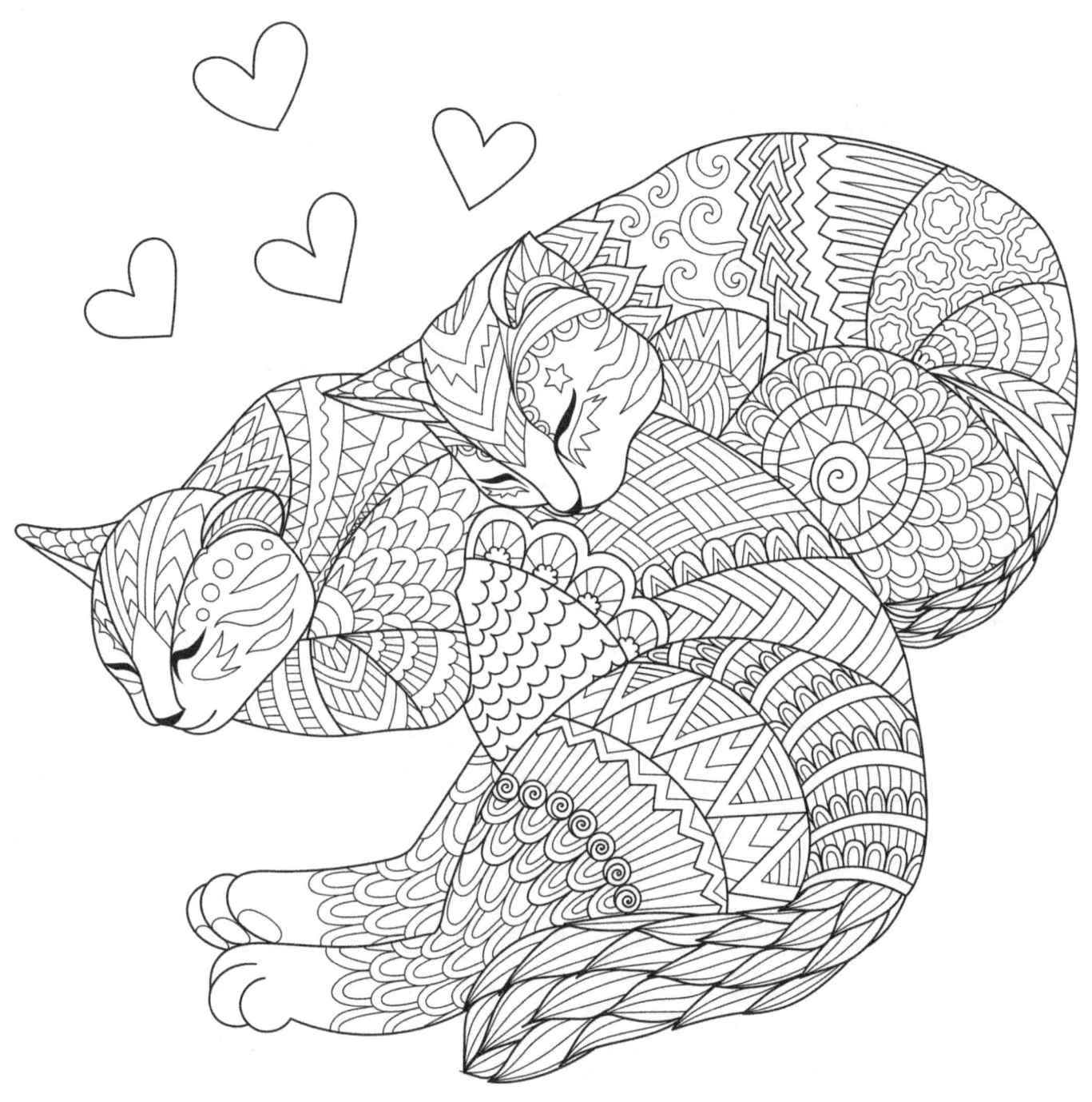

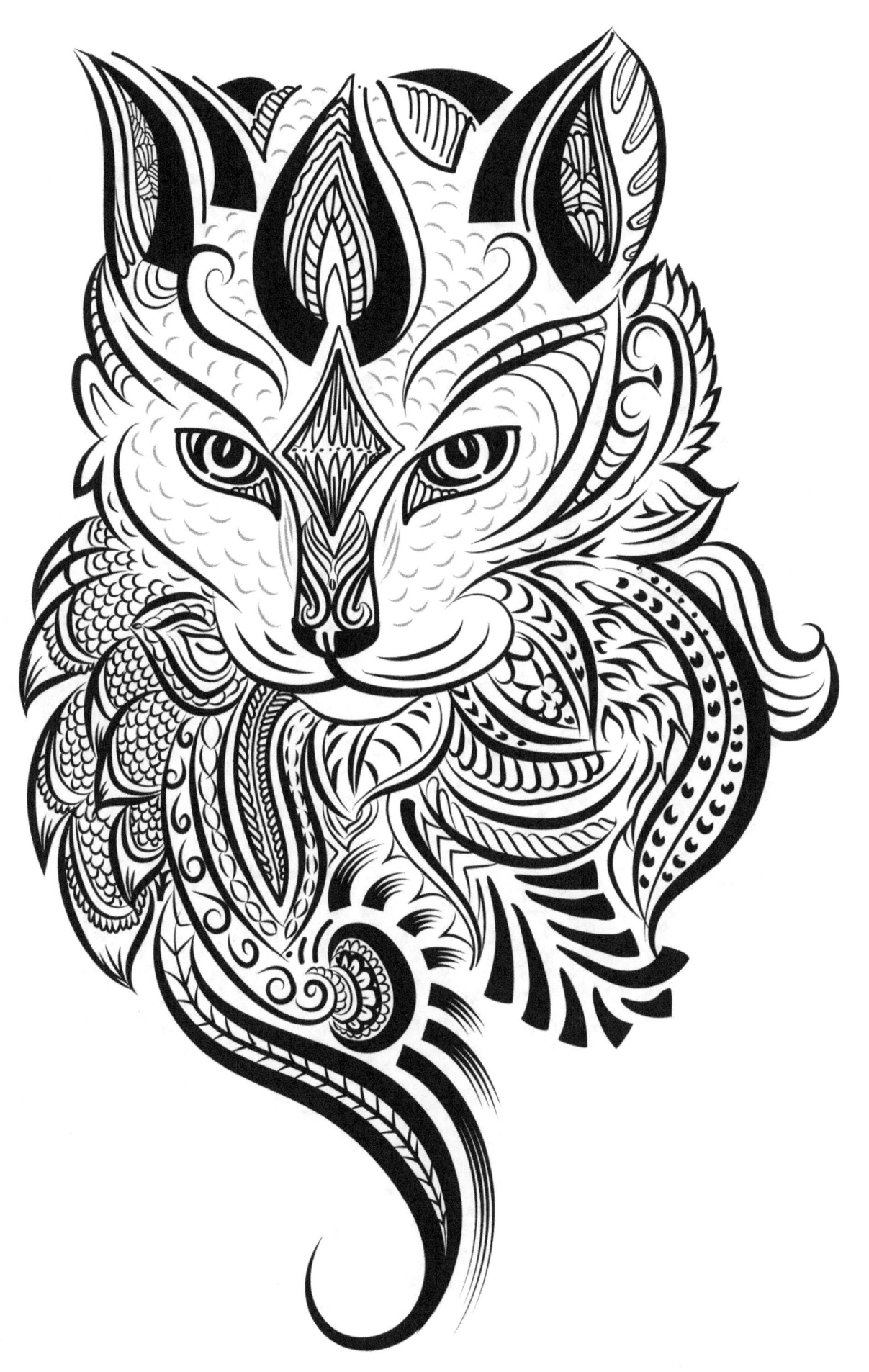

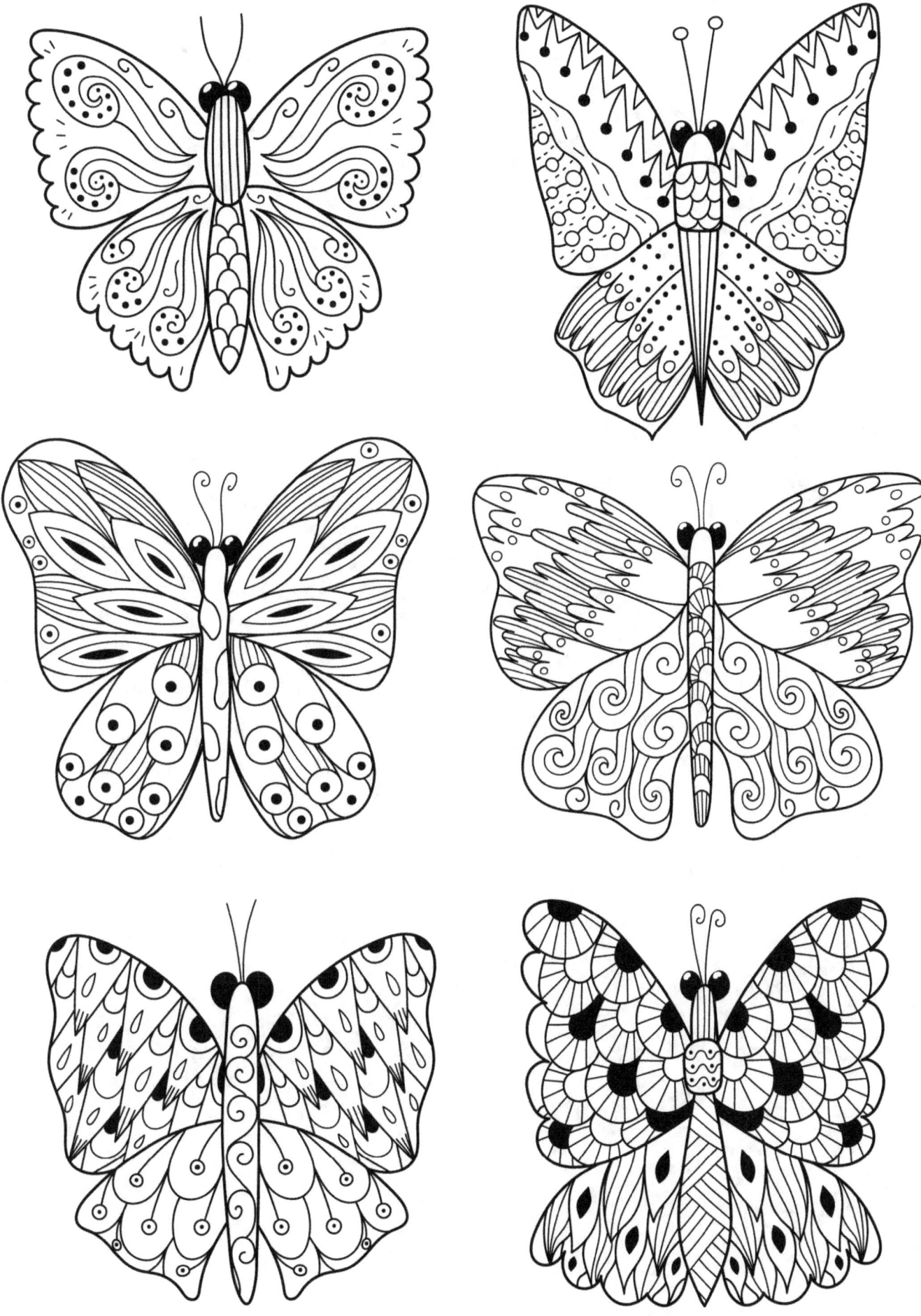

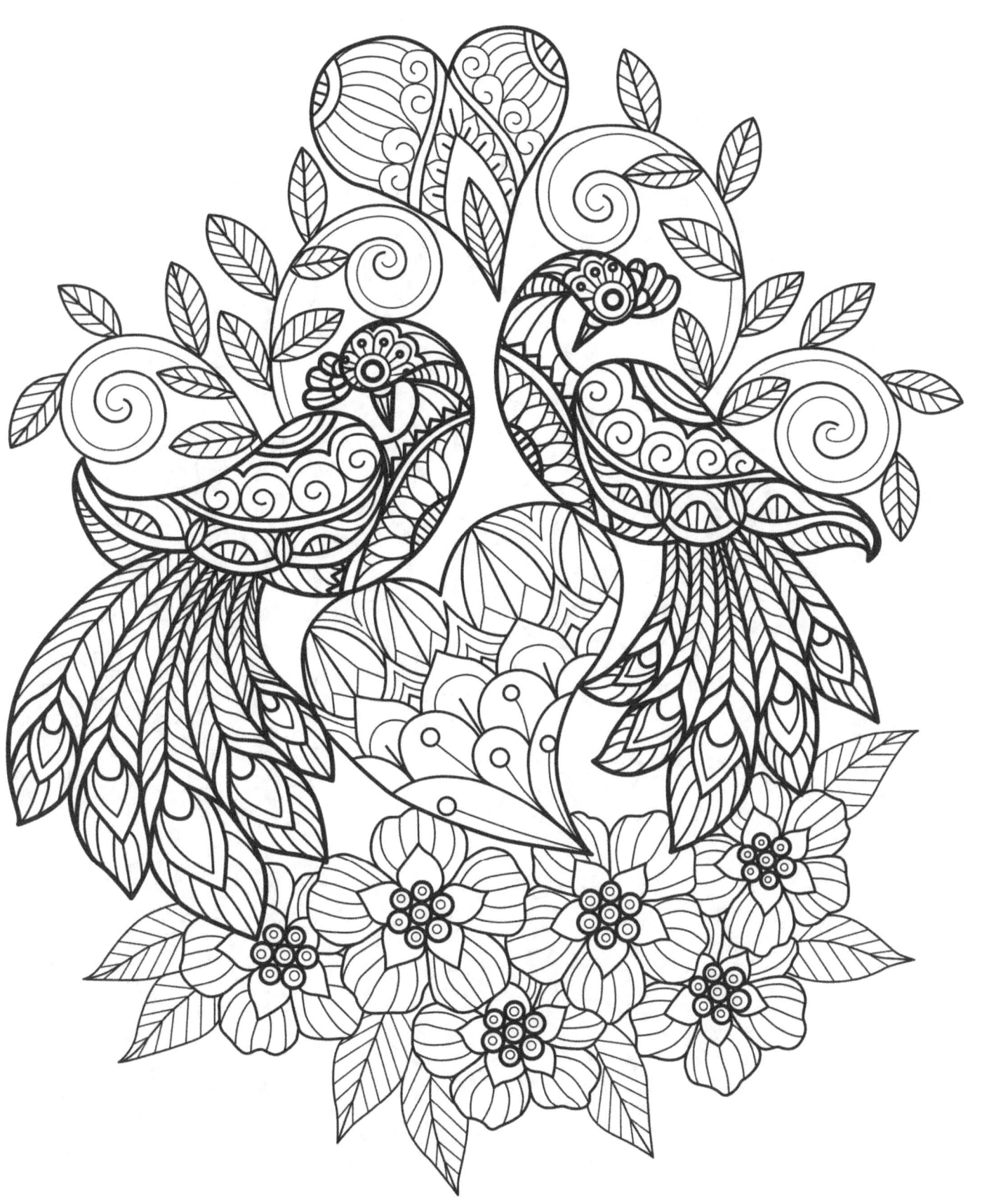

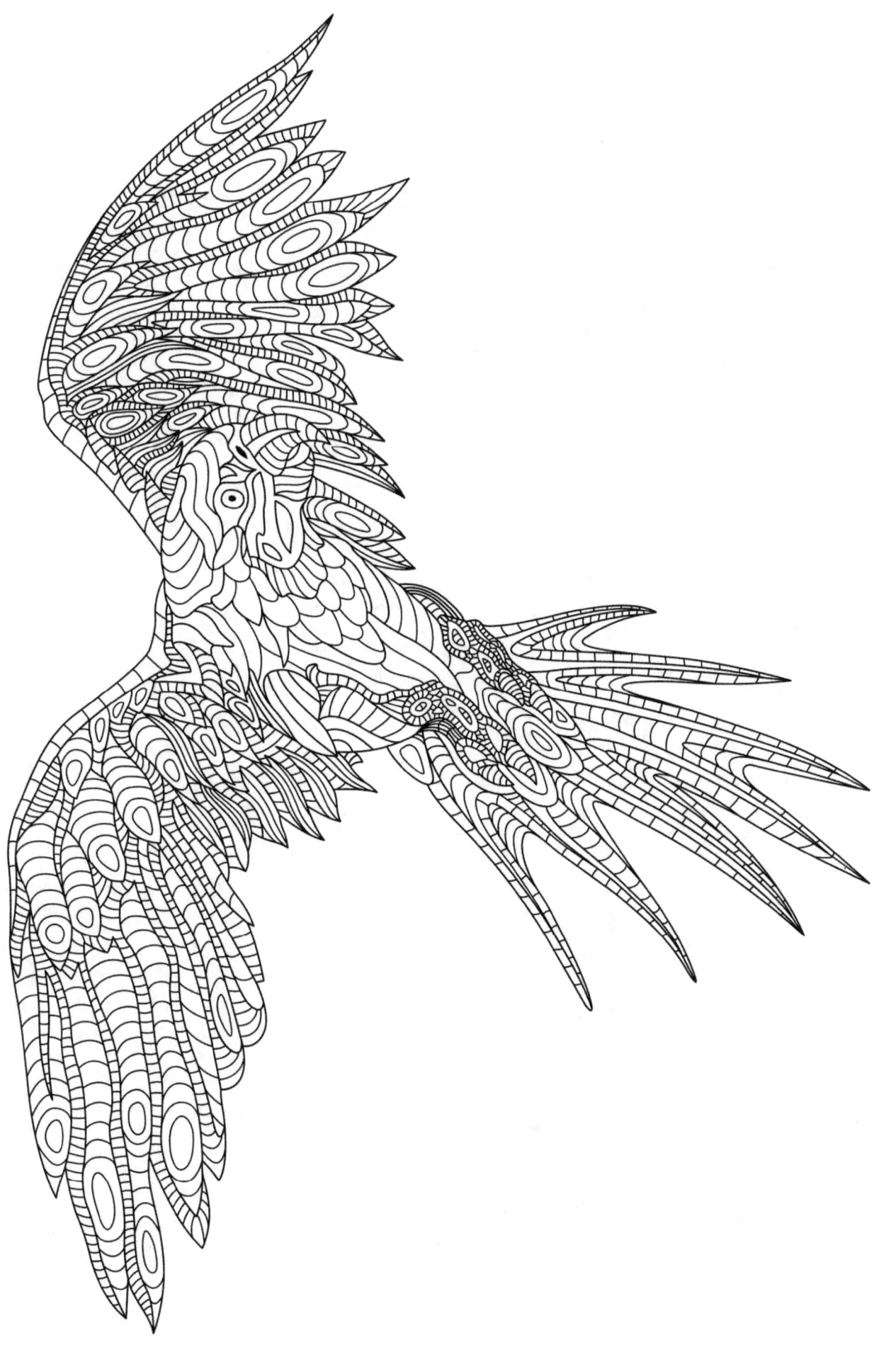

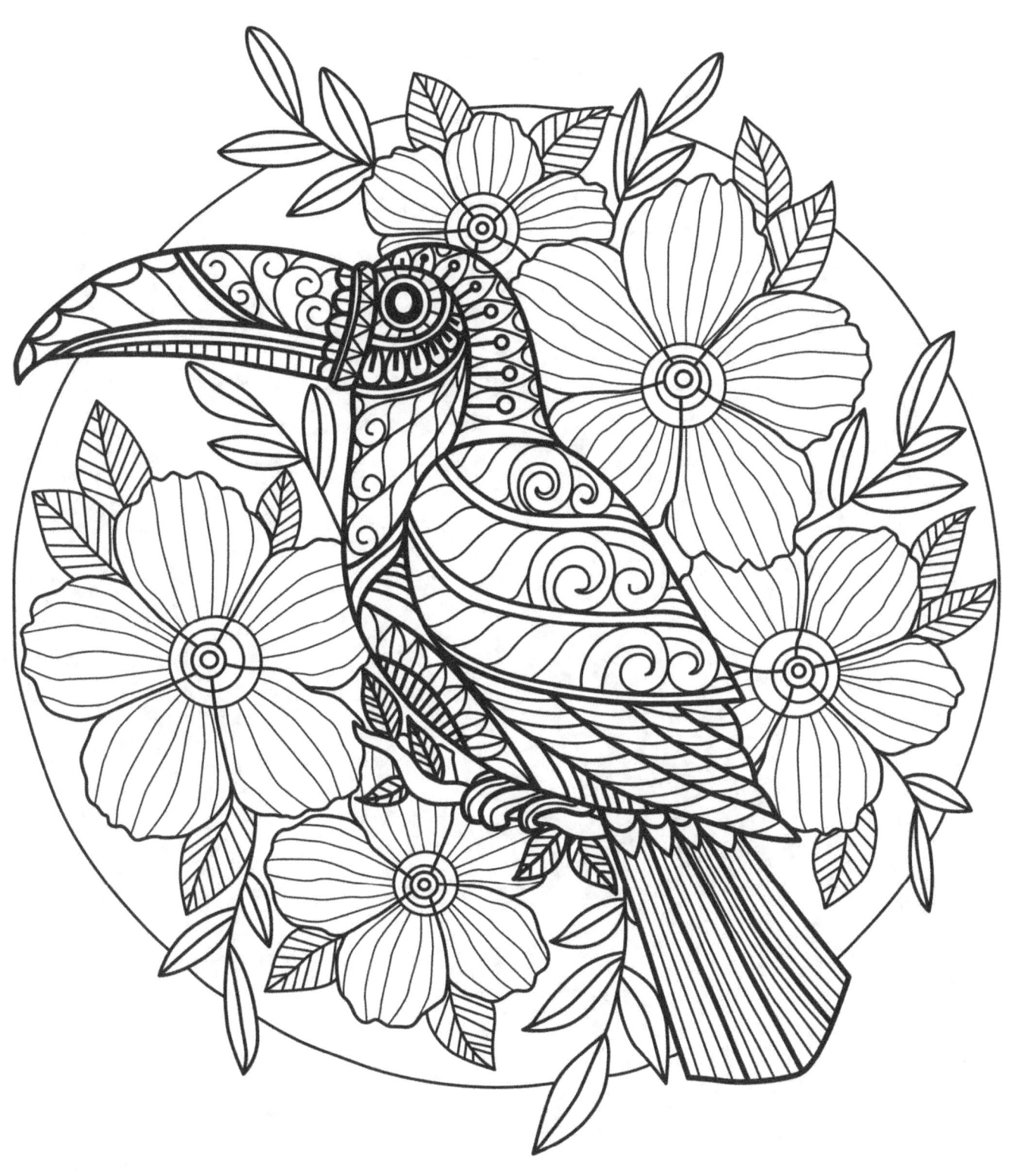

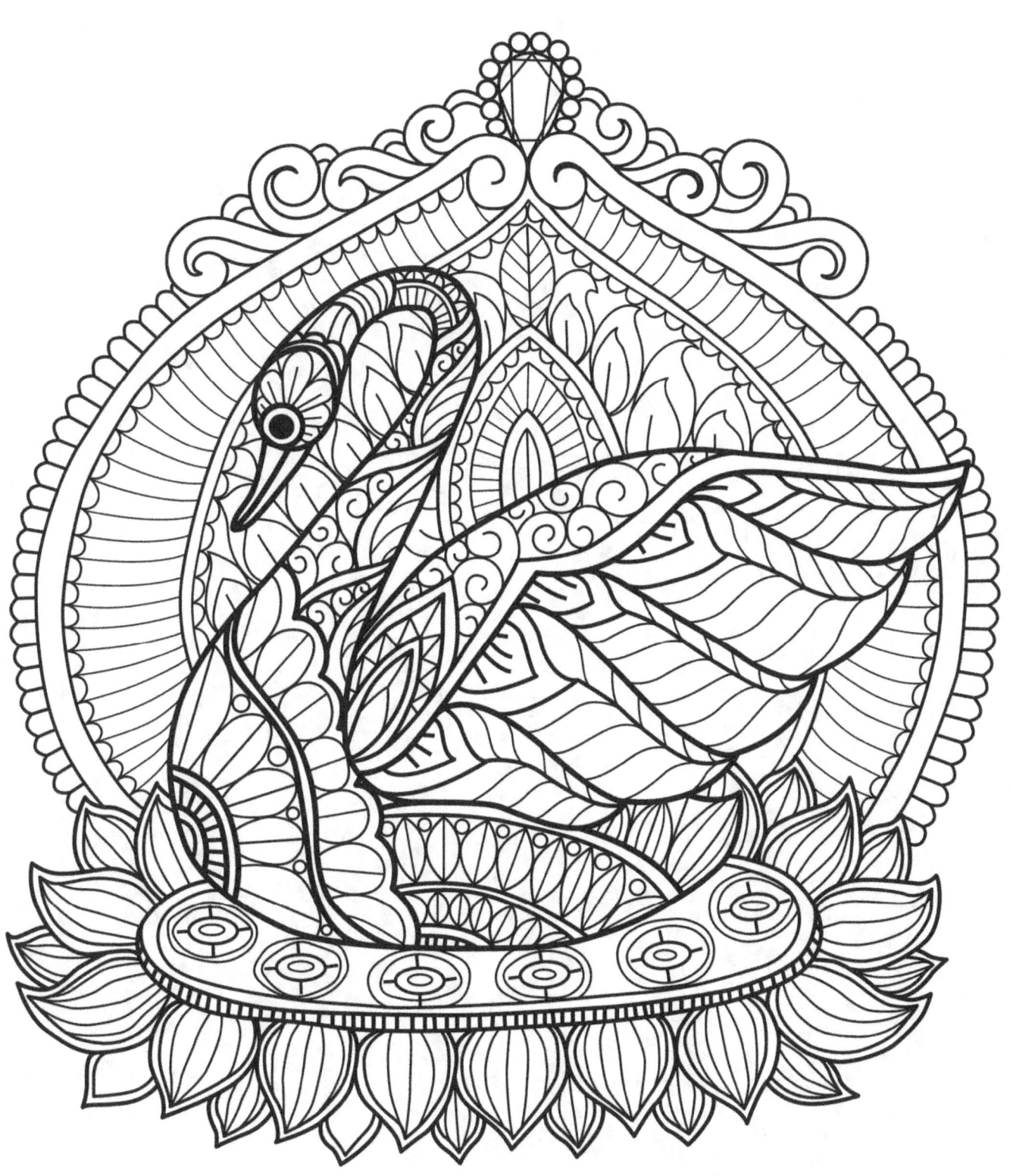

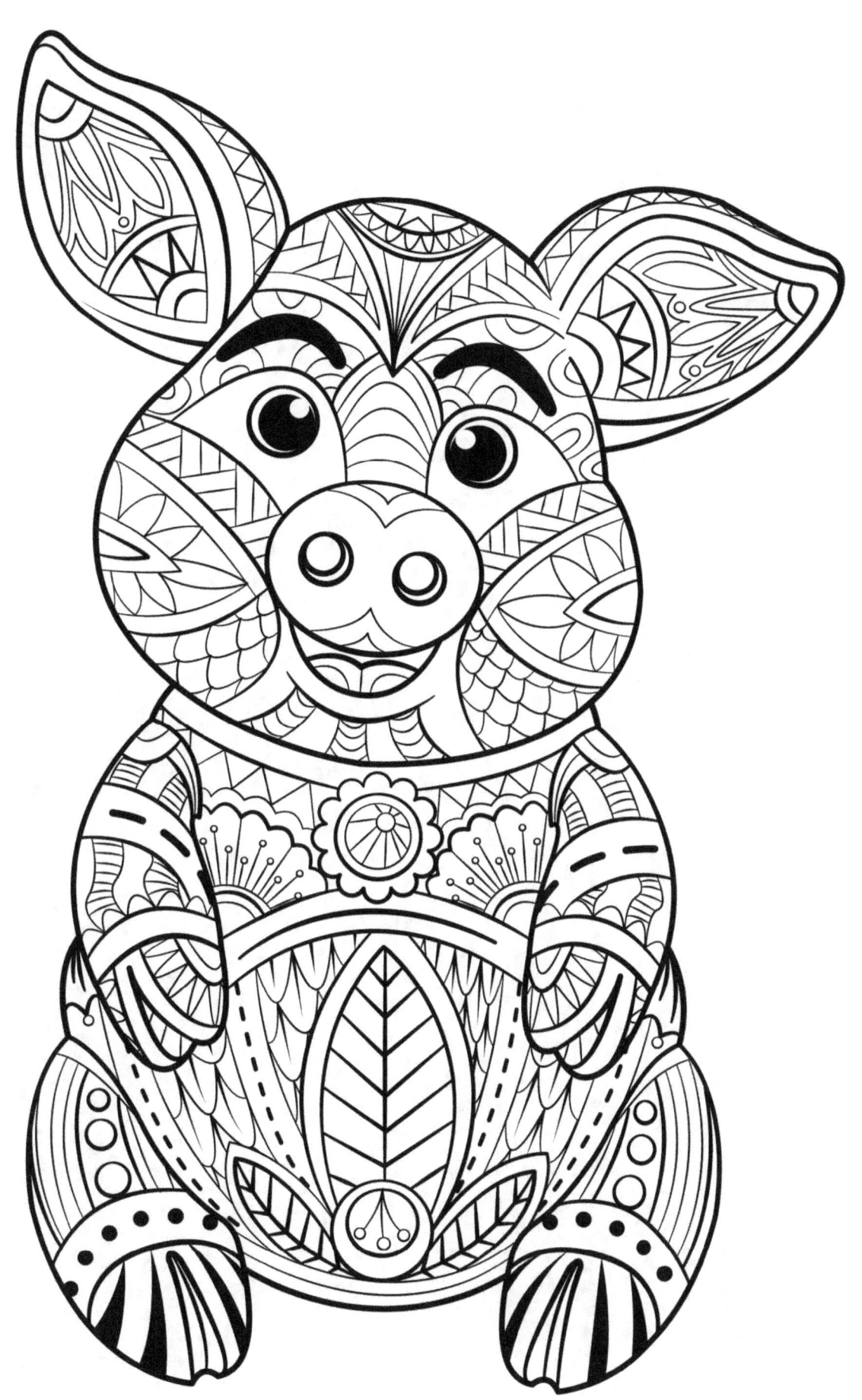

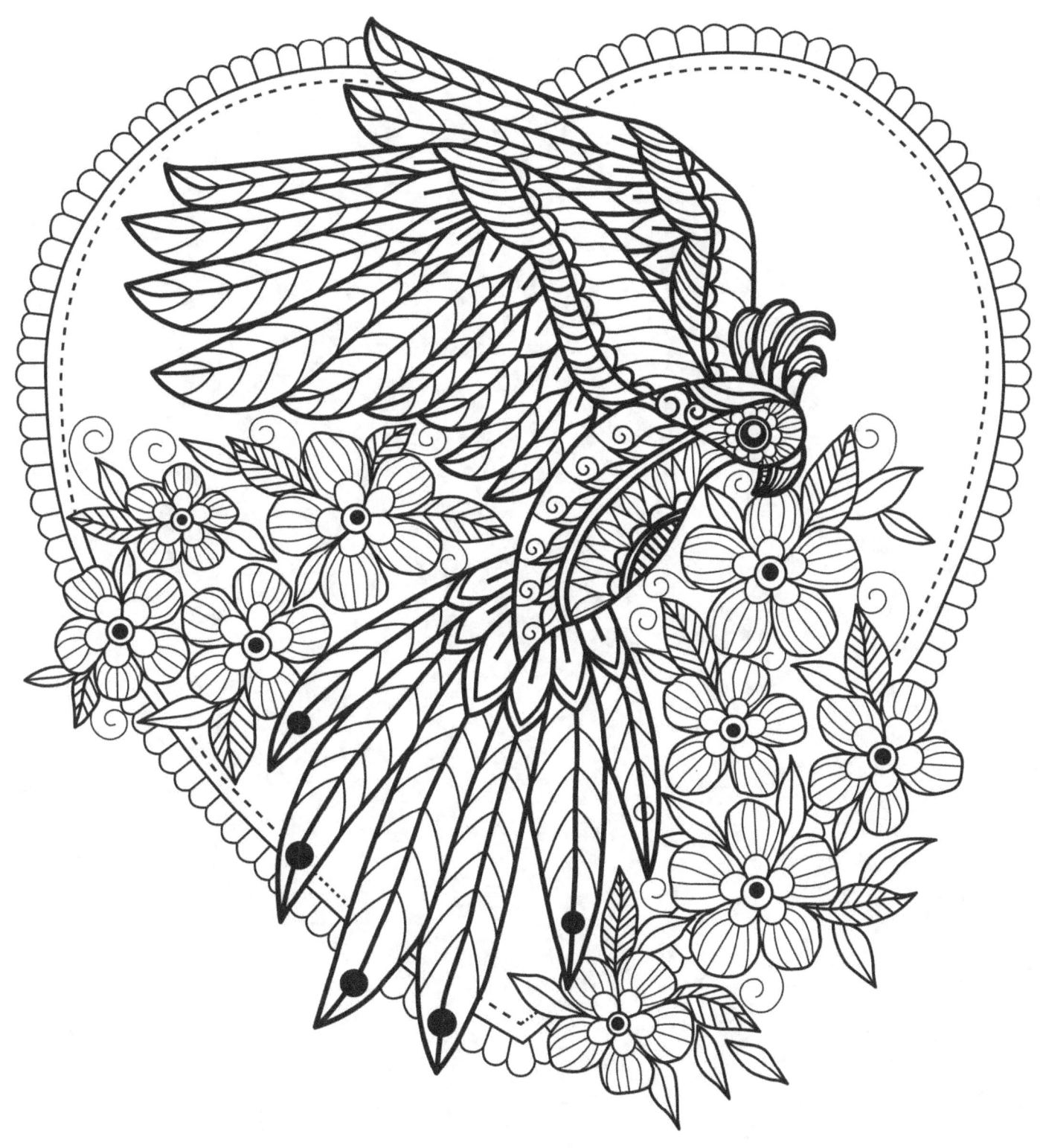

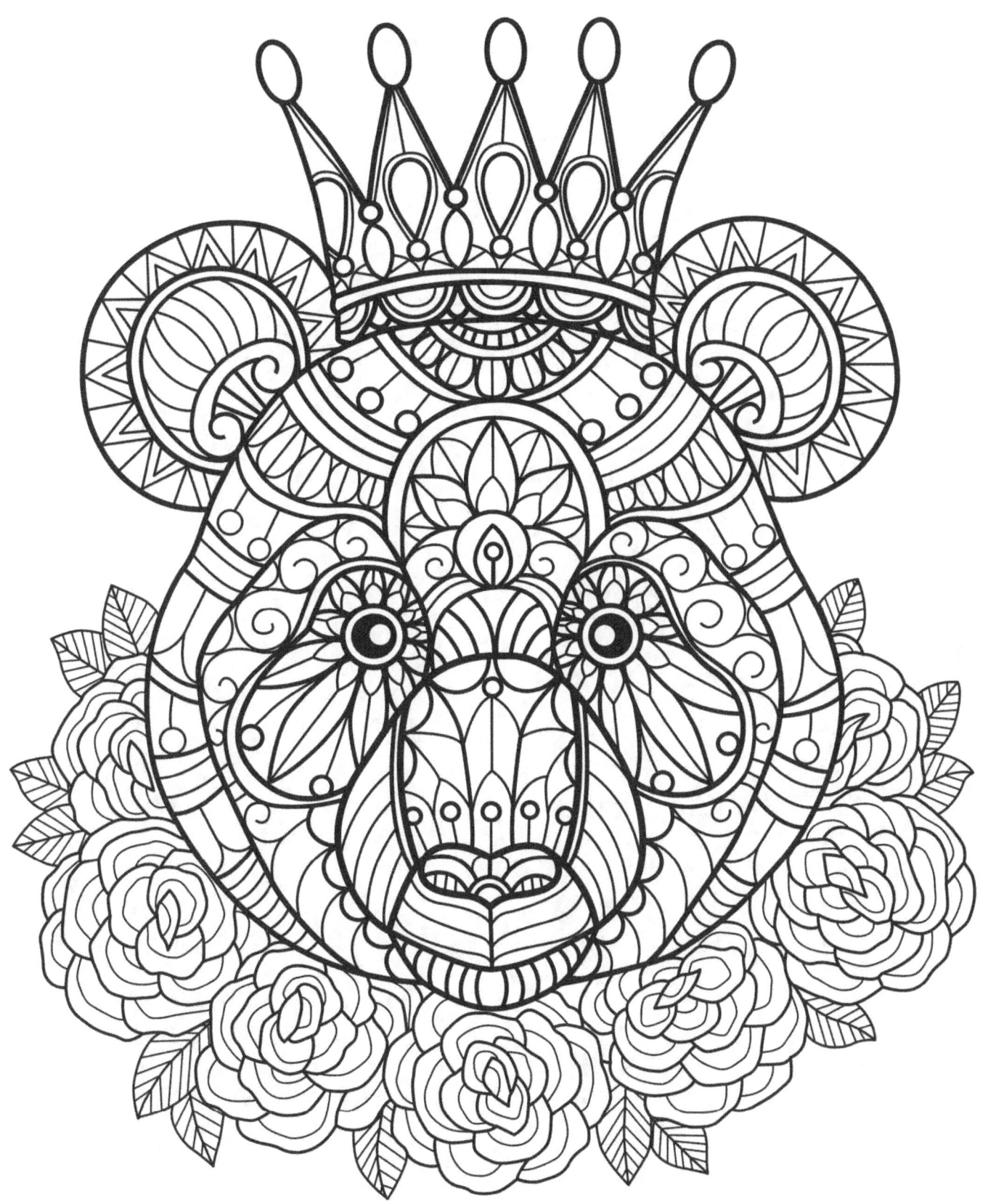

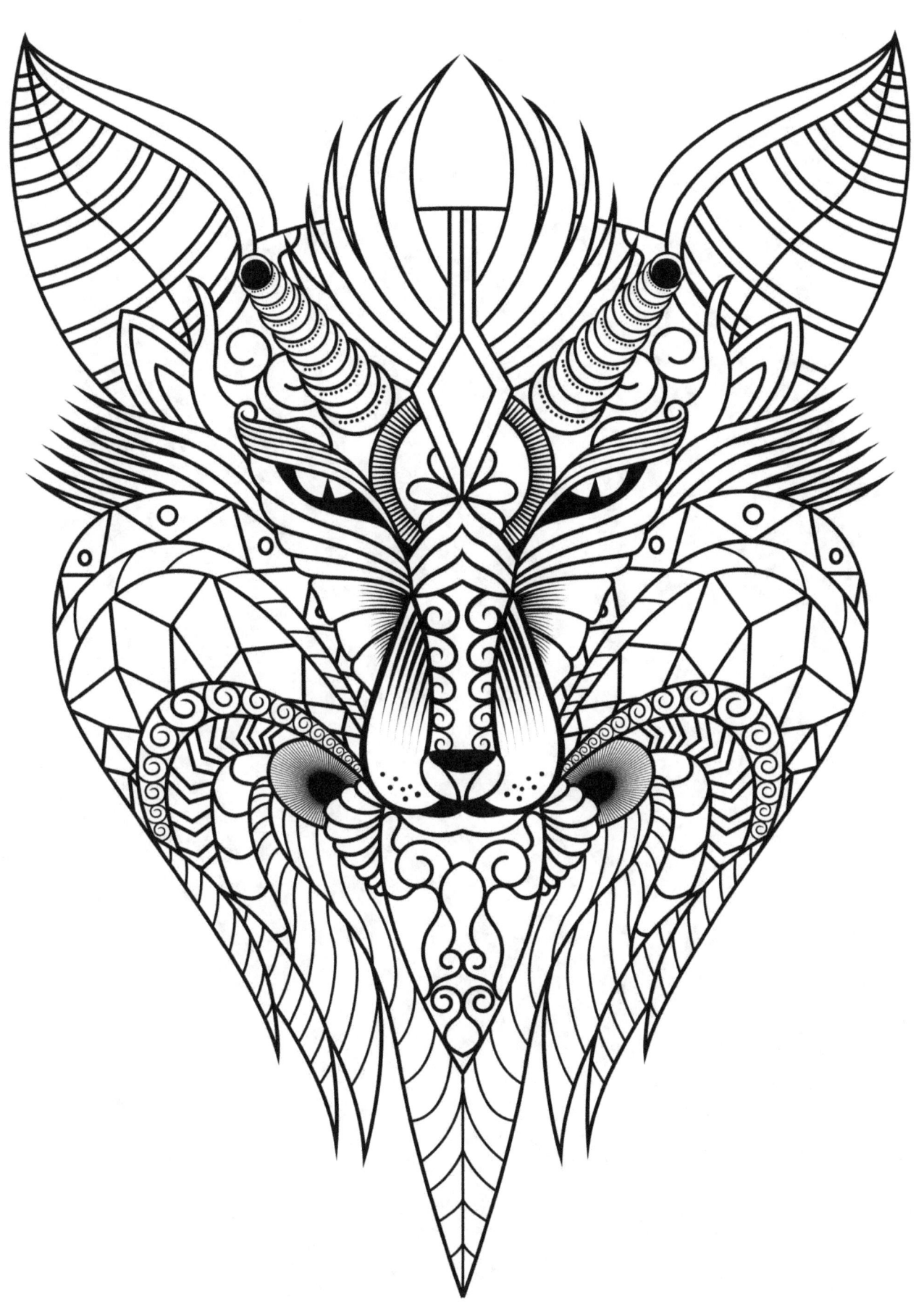

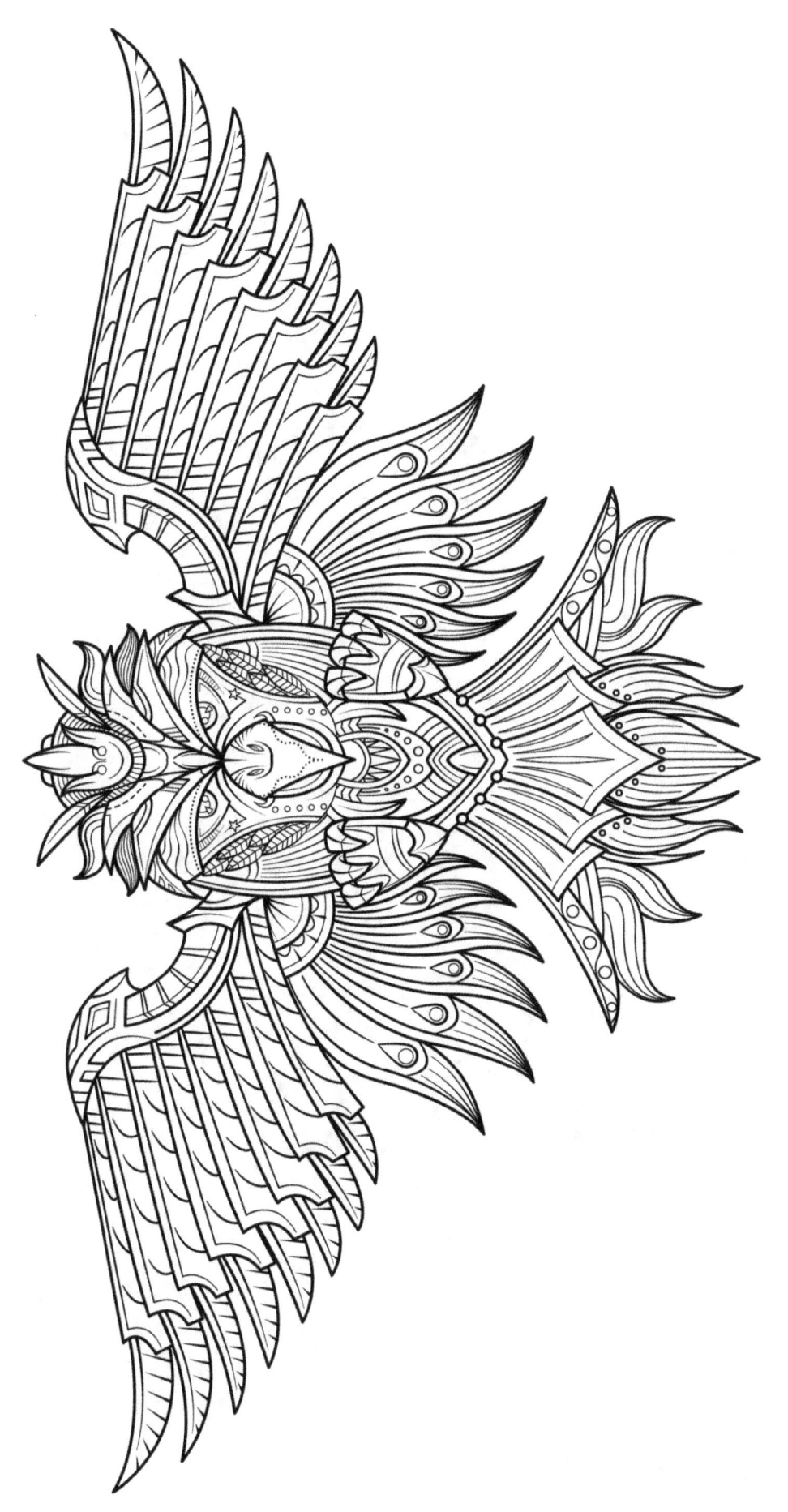

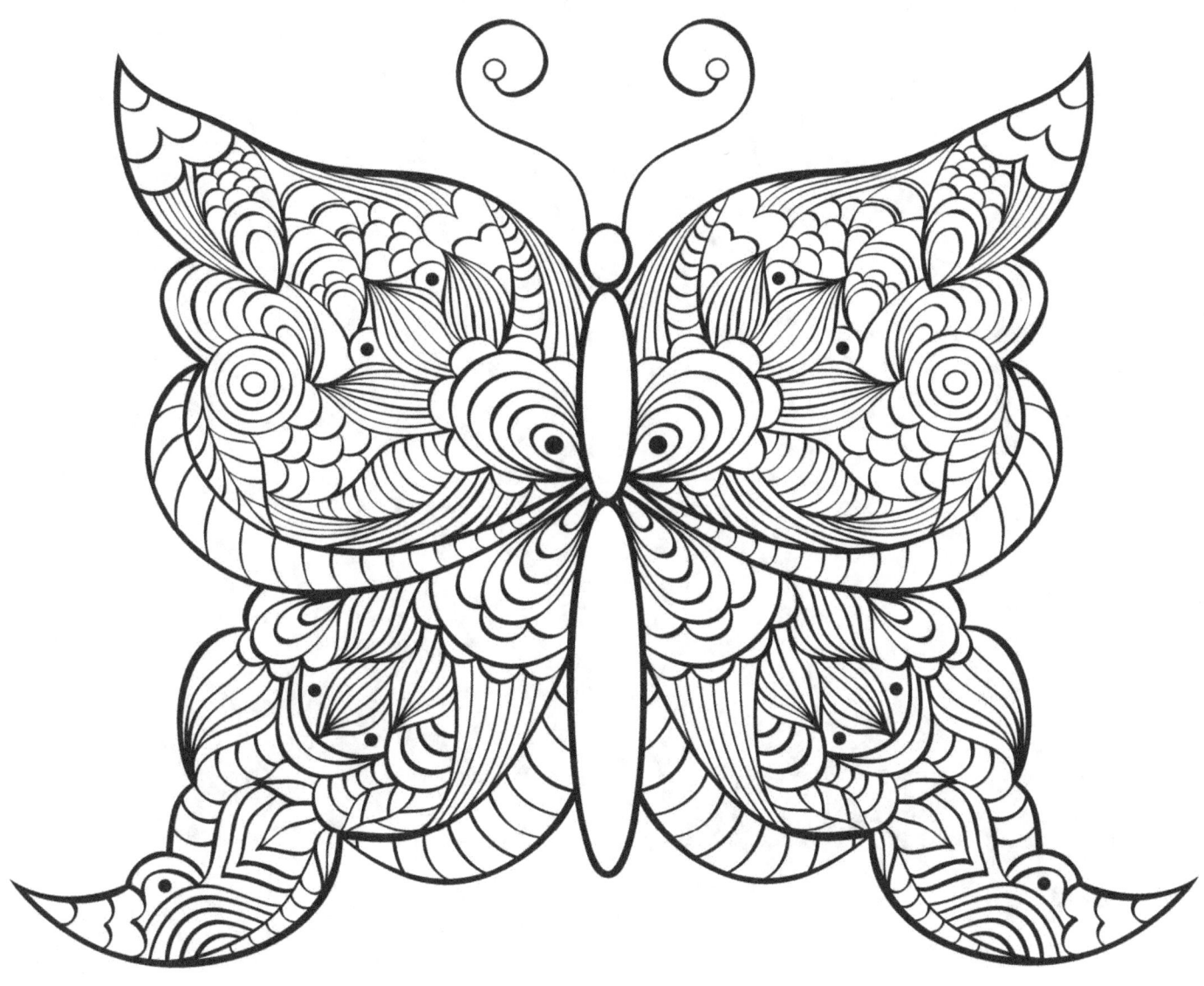

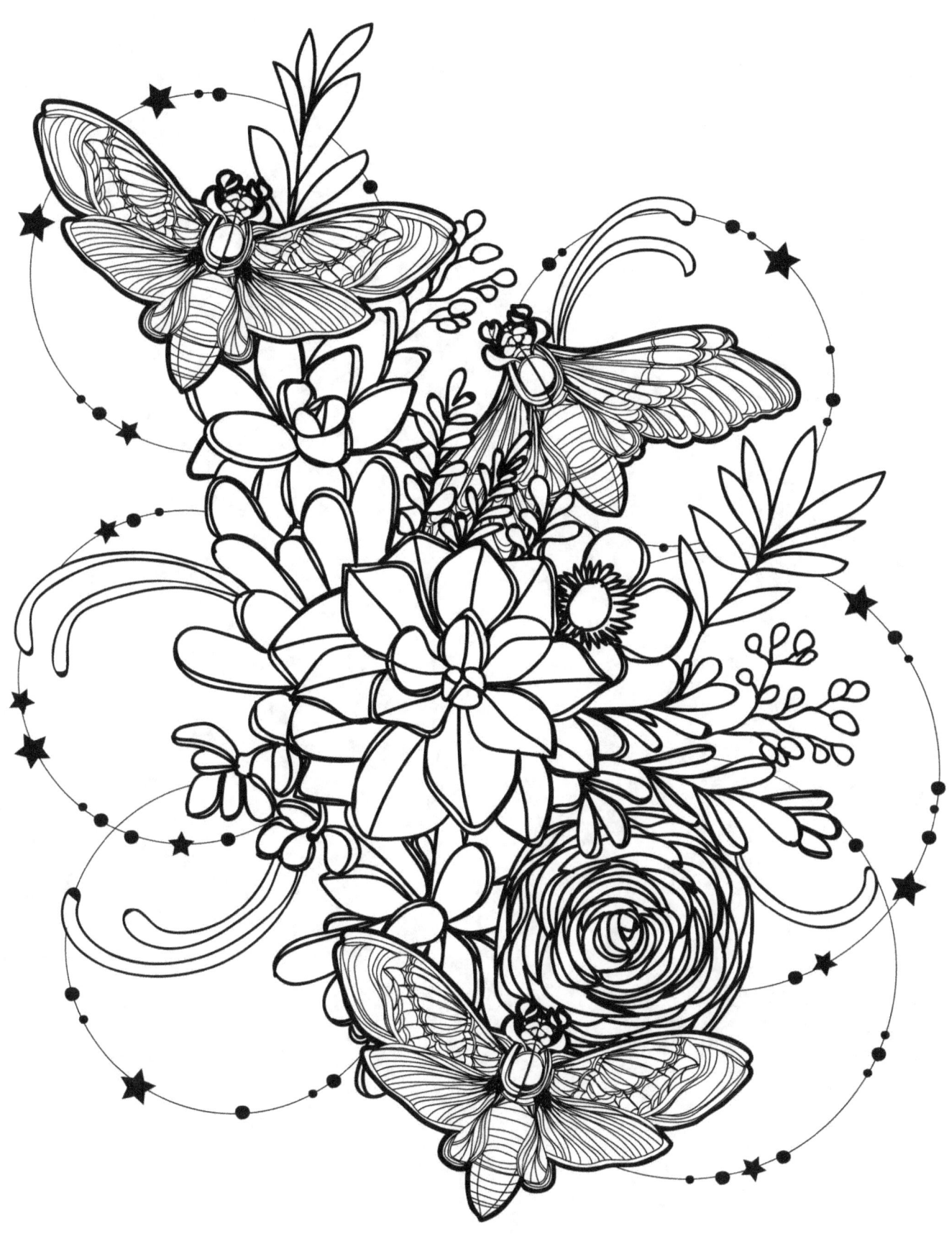

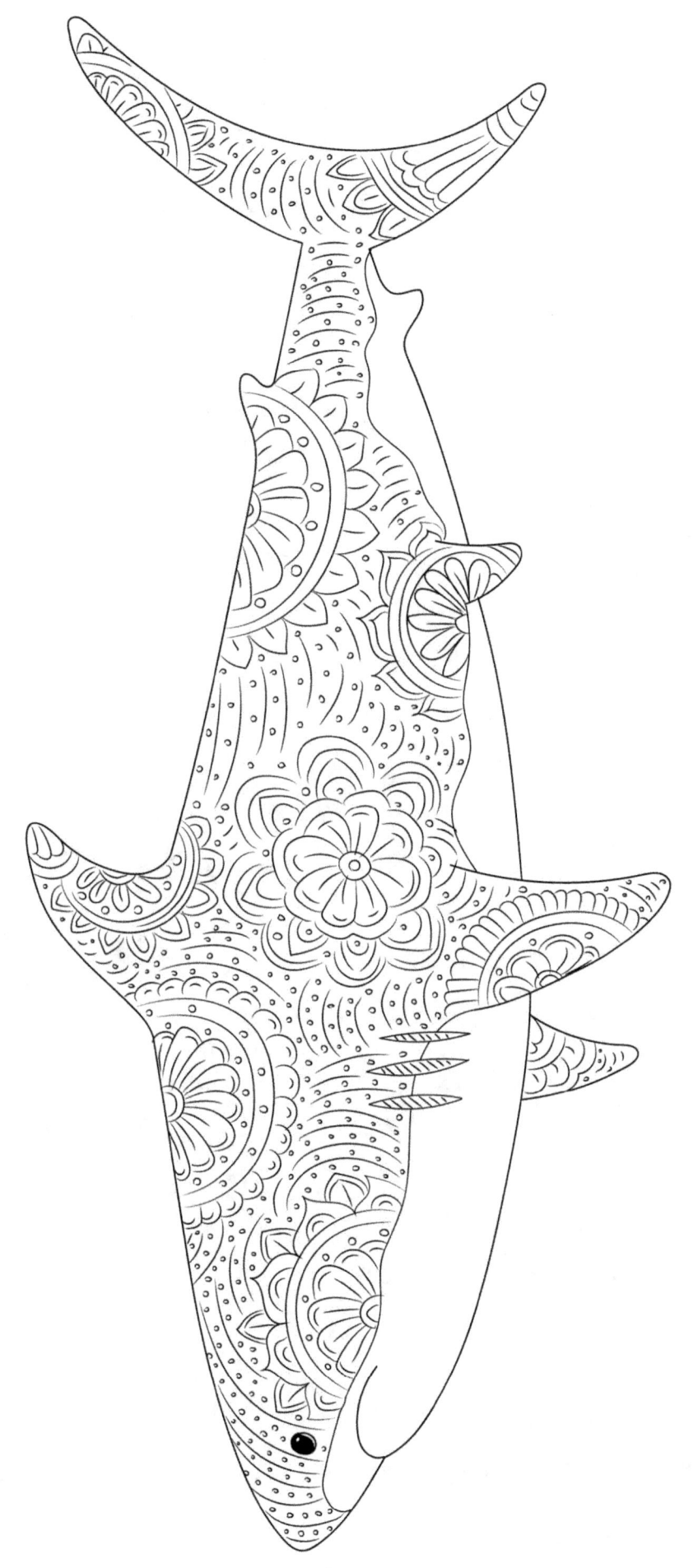

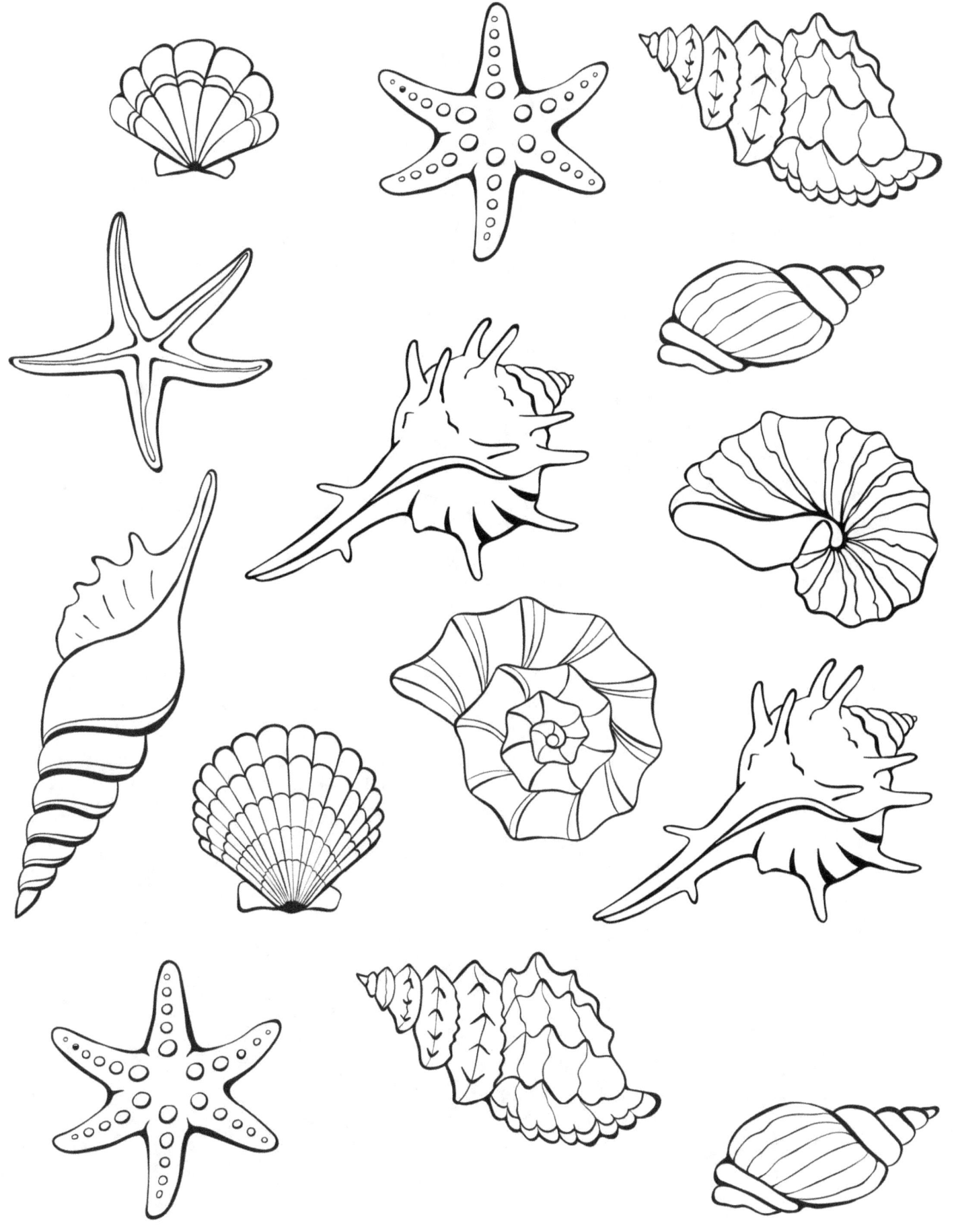

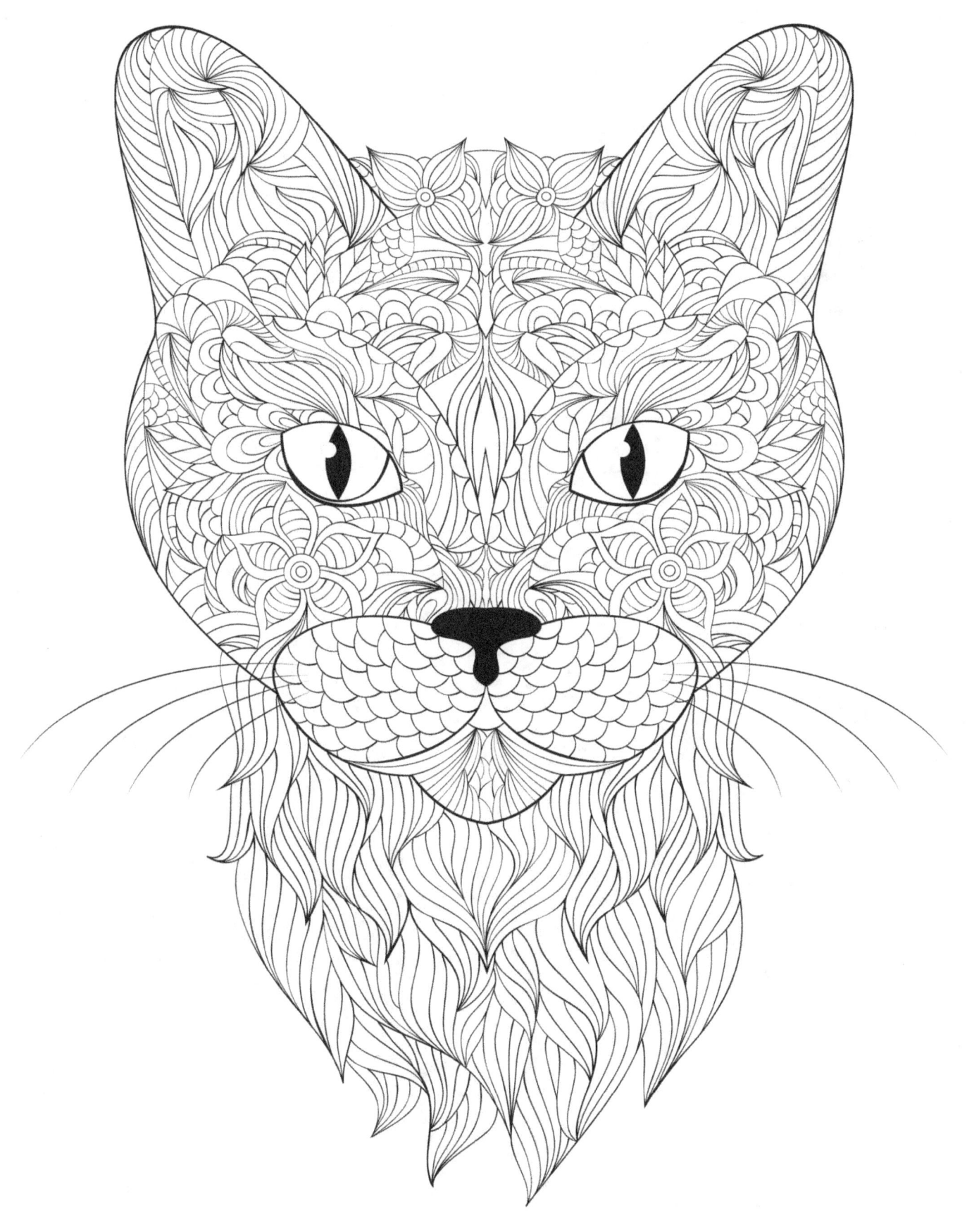

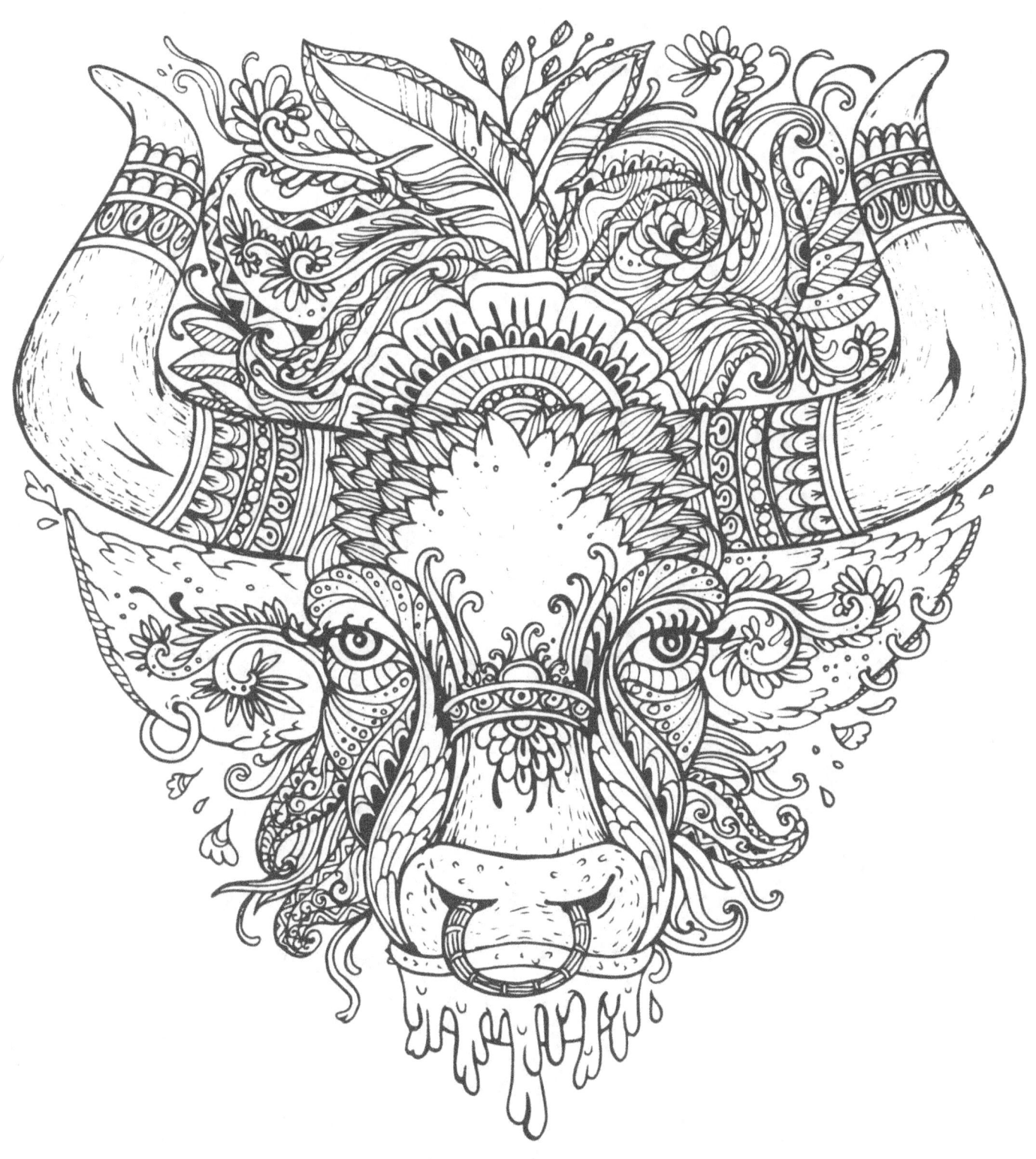

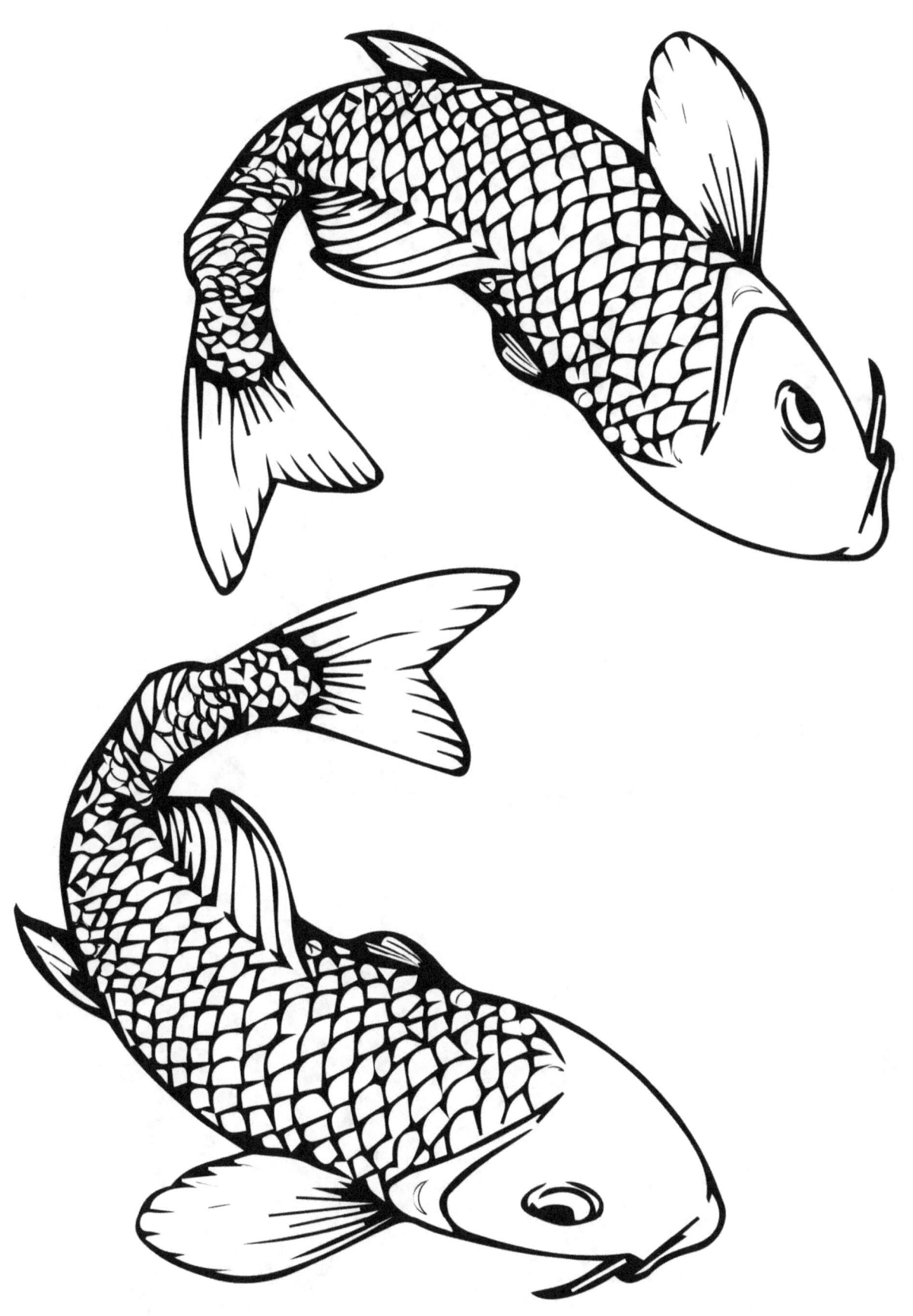

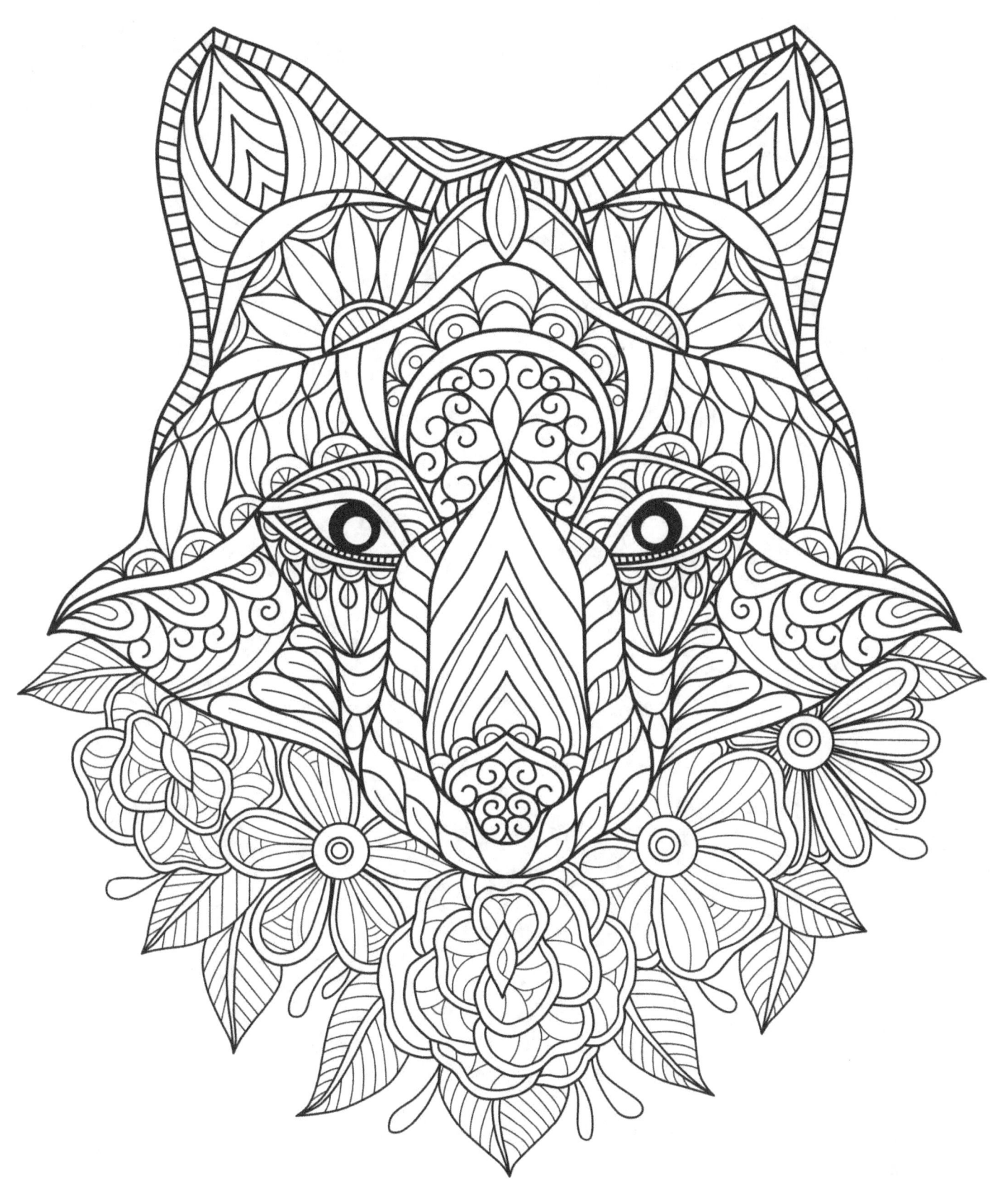

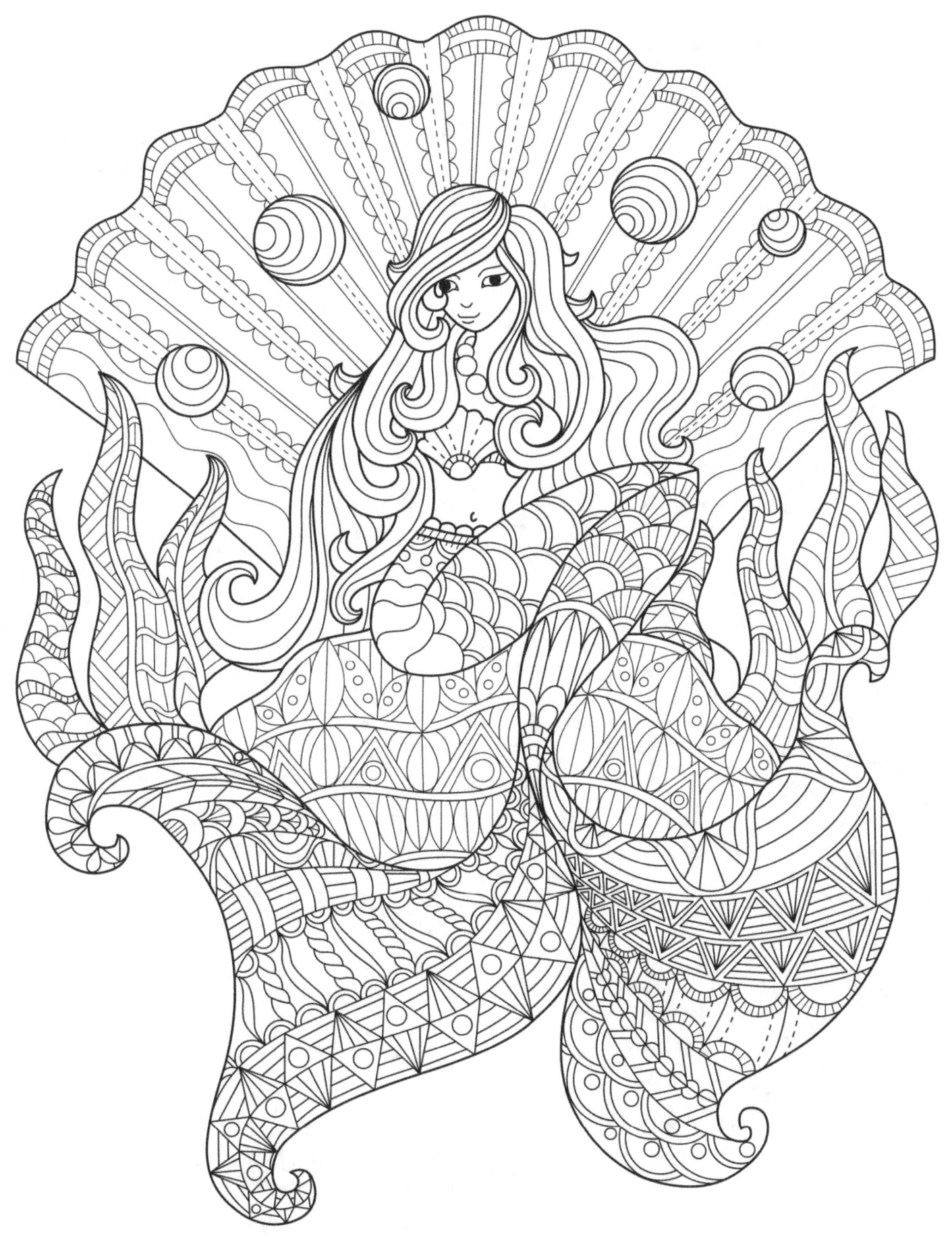

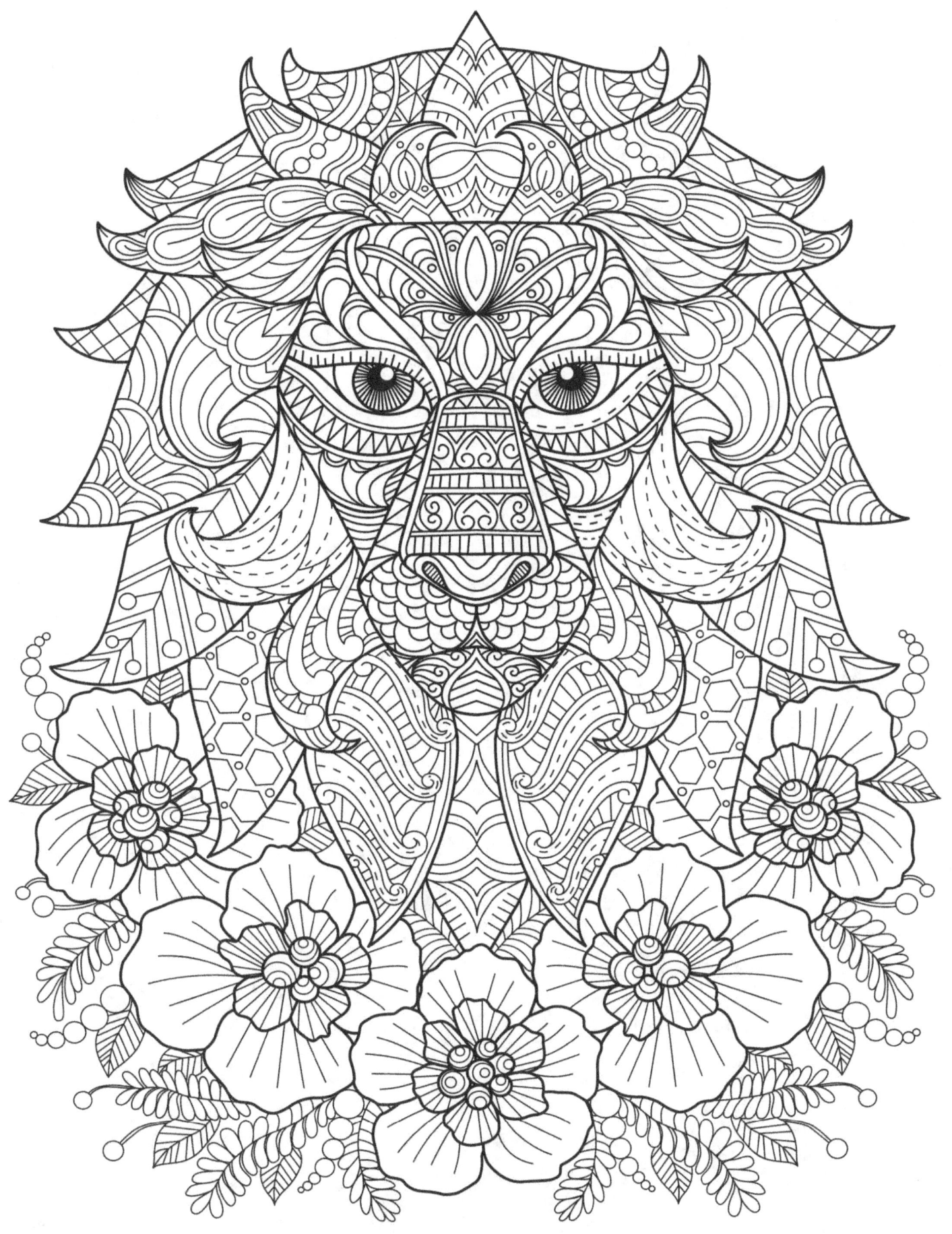

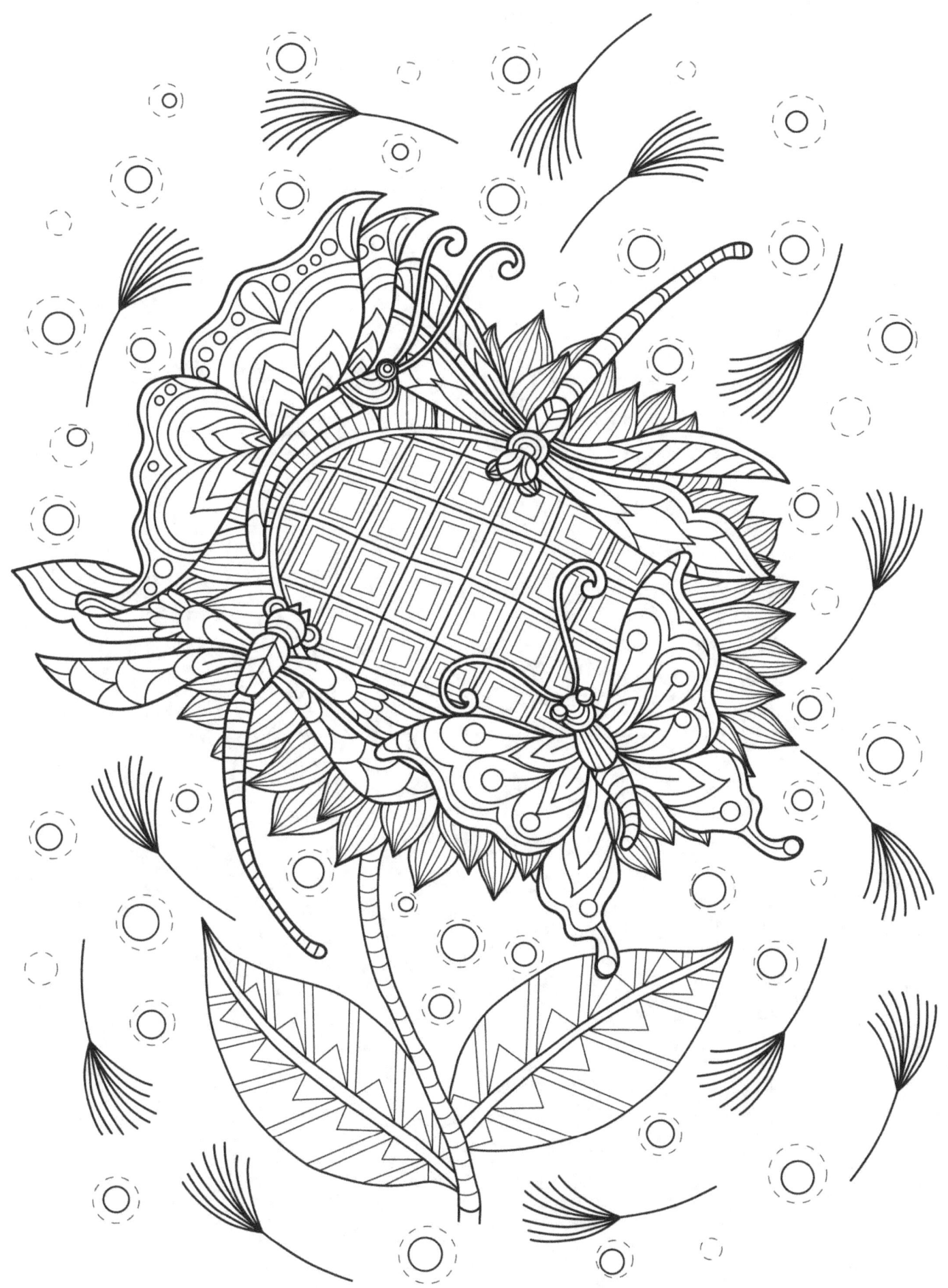

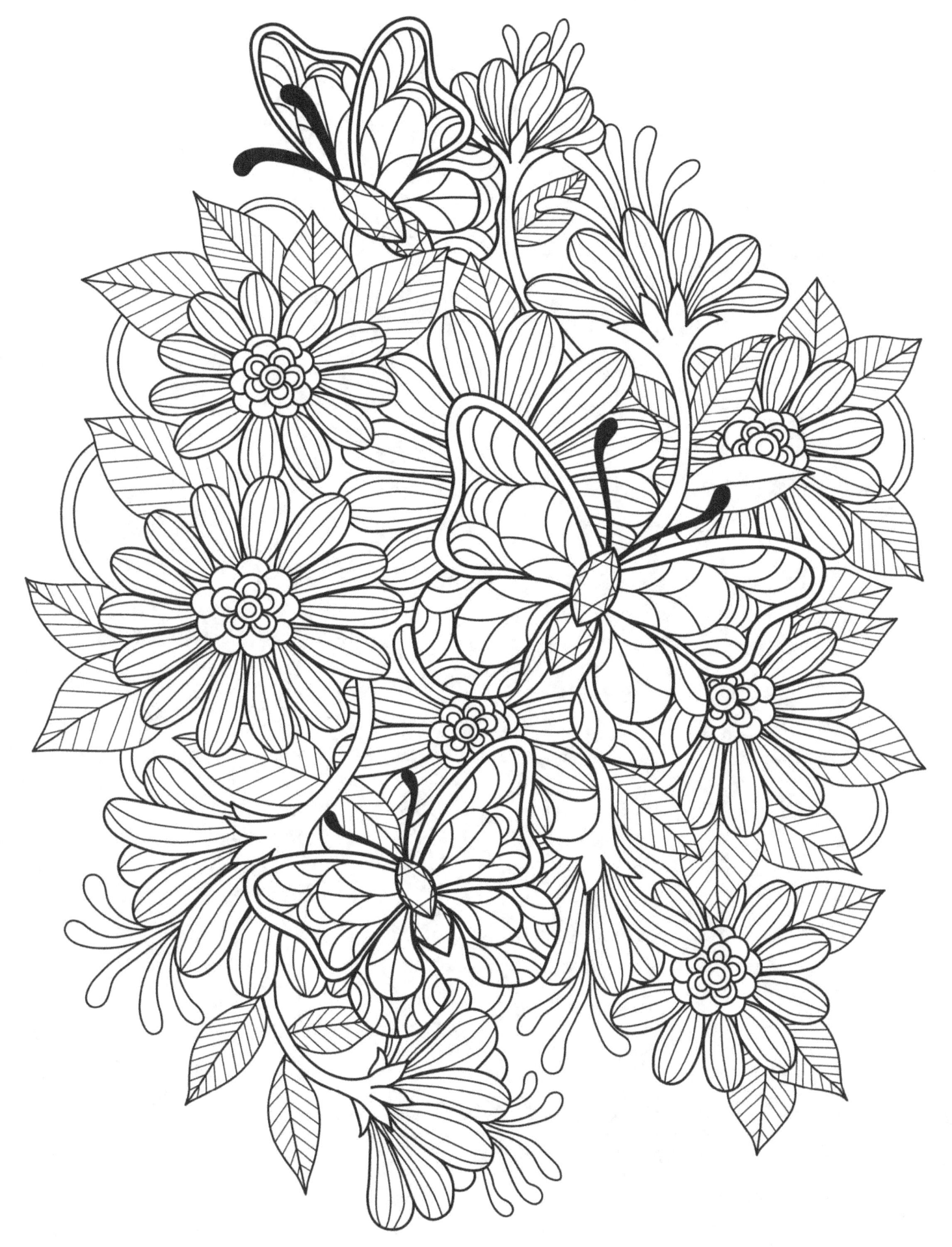

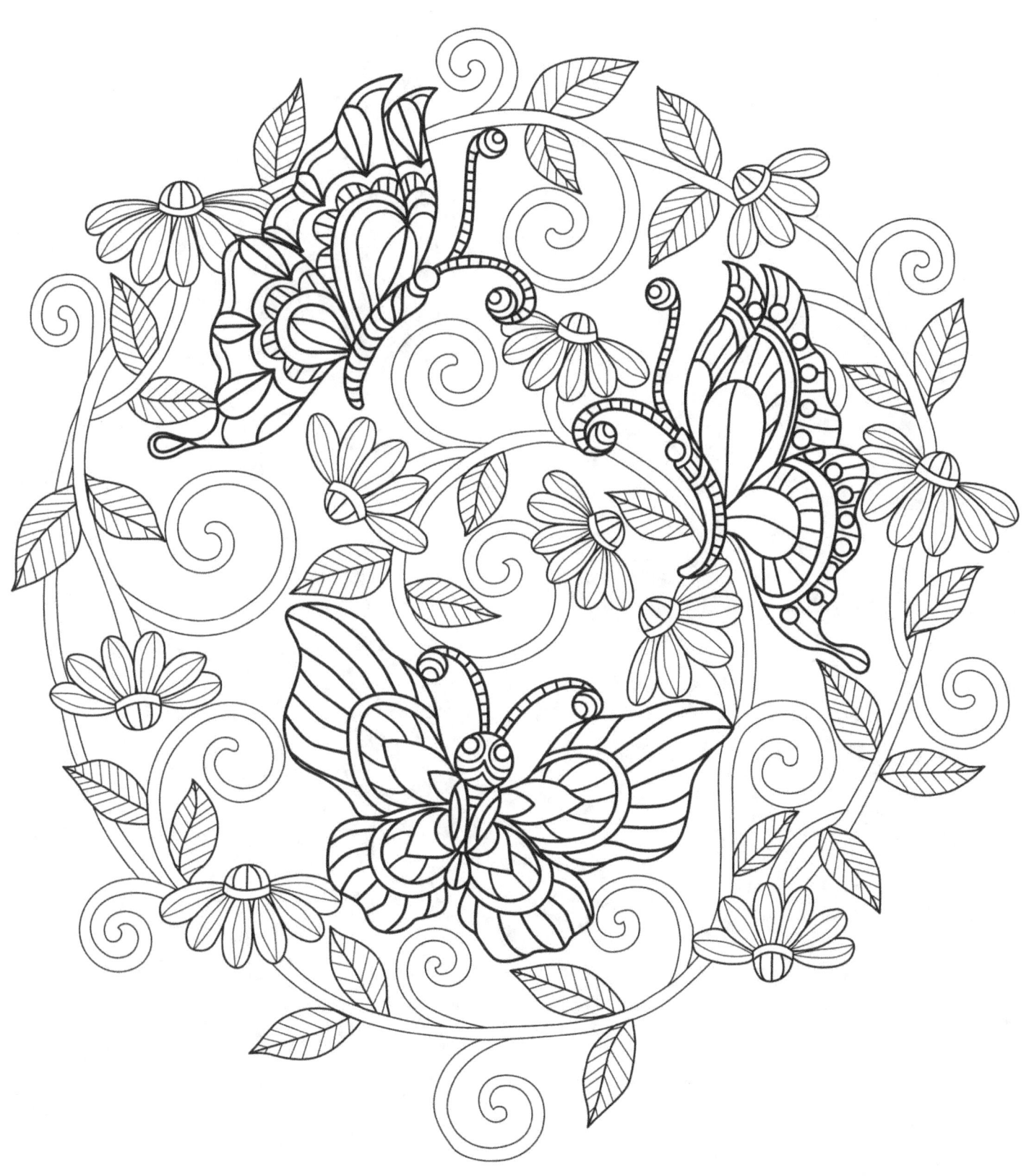

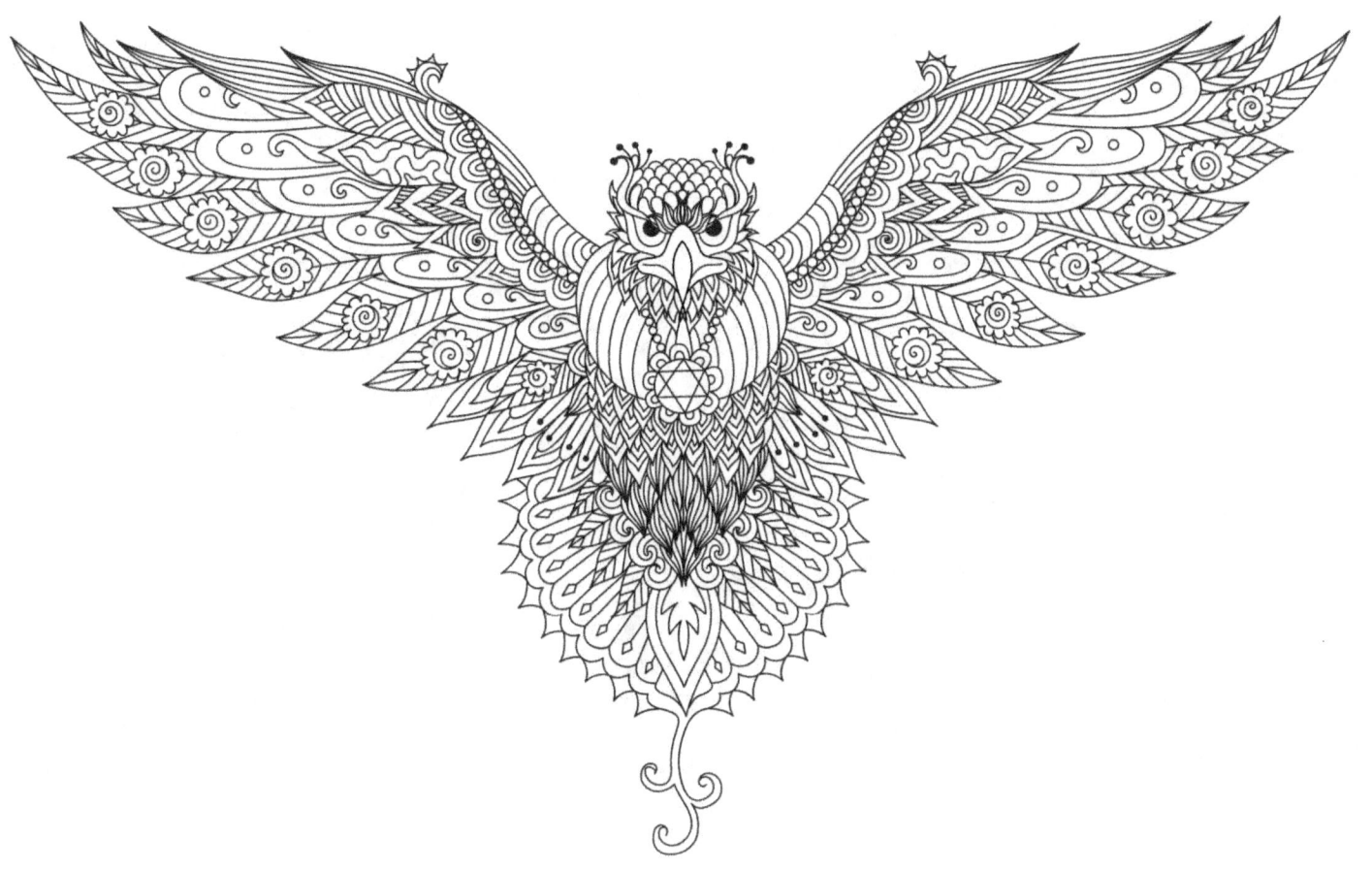

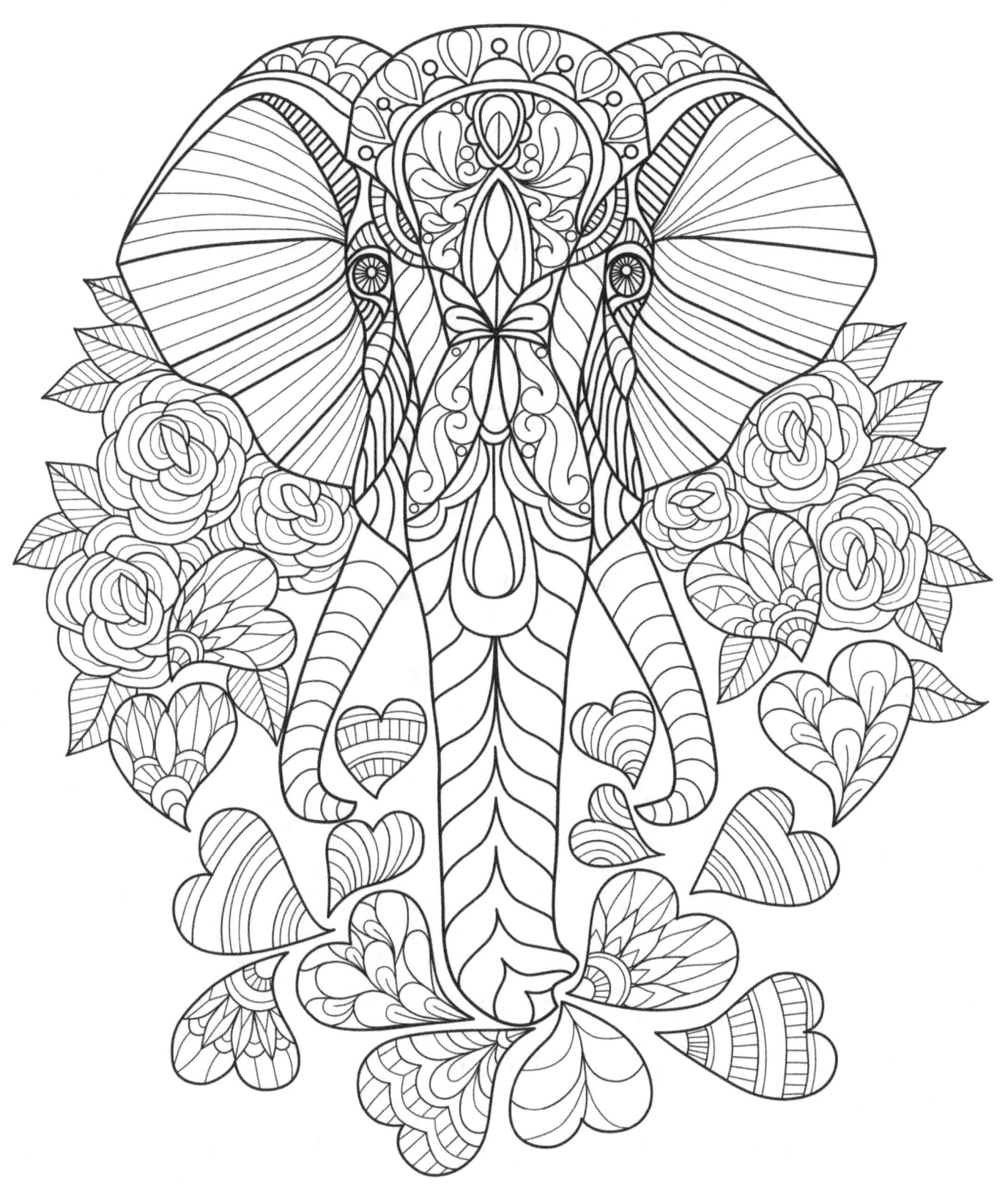

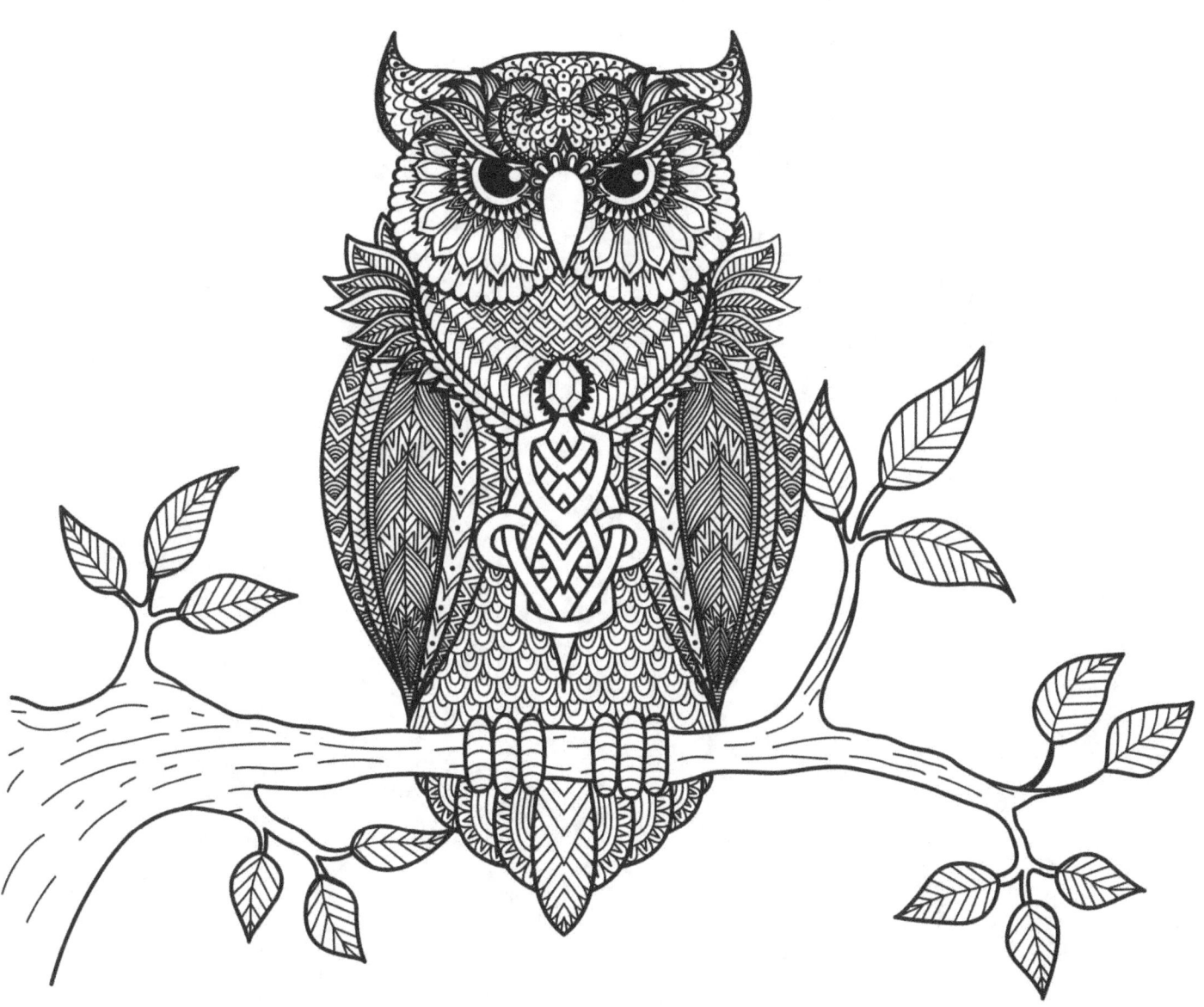

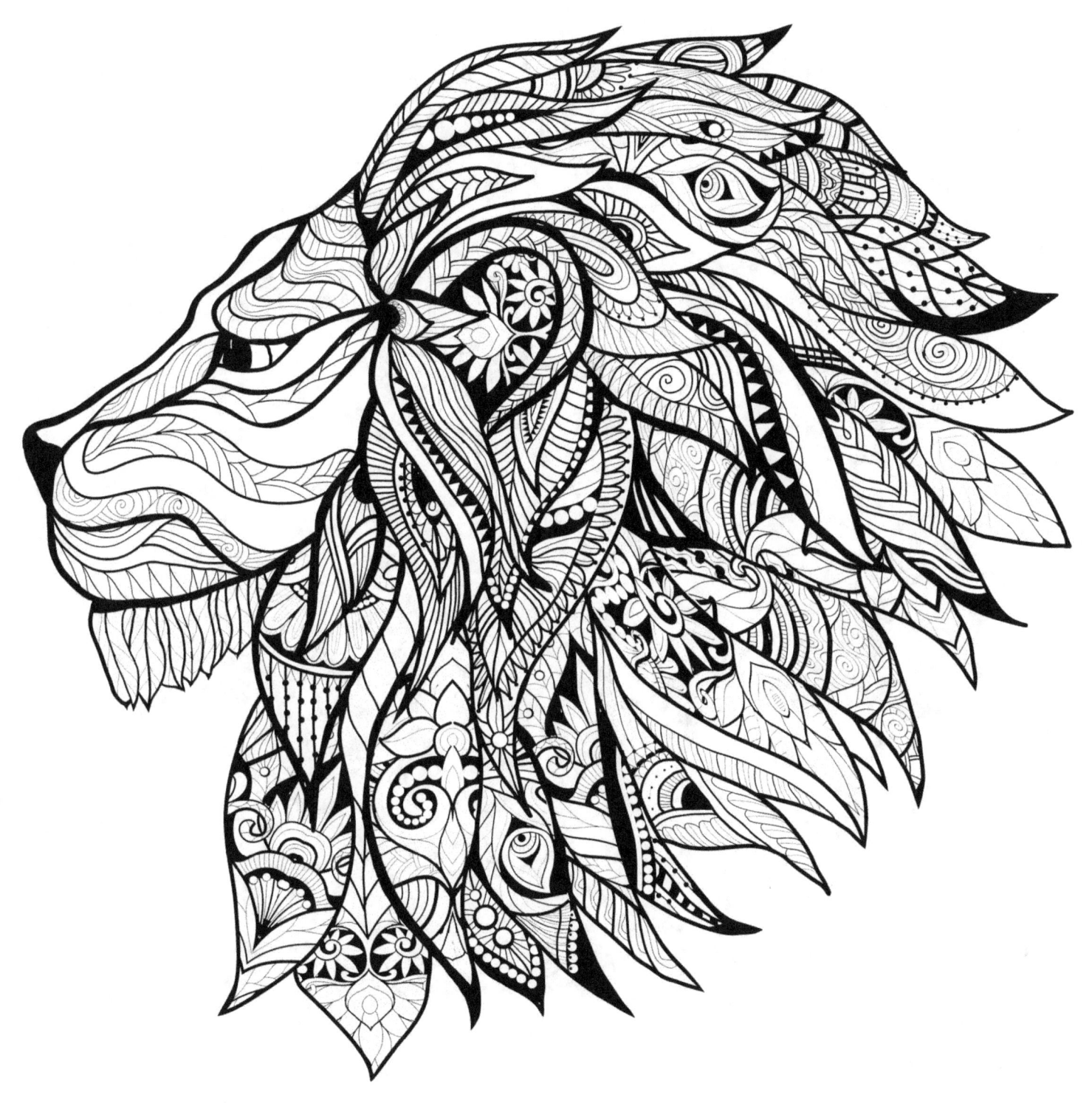

Test Color

Test Color

www.ingramcontent.com/pod-product-compliance
Lightning Source LLC
Chambersburg PA
CBHW080557220526
45466CB00010B/3177